BOTTICELLI

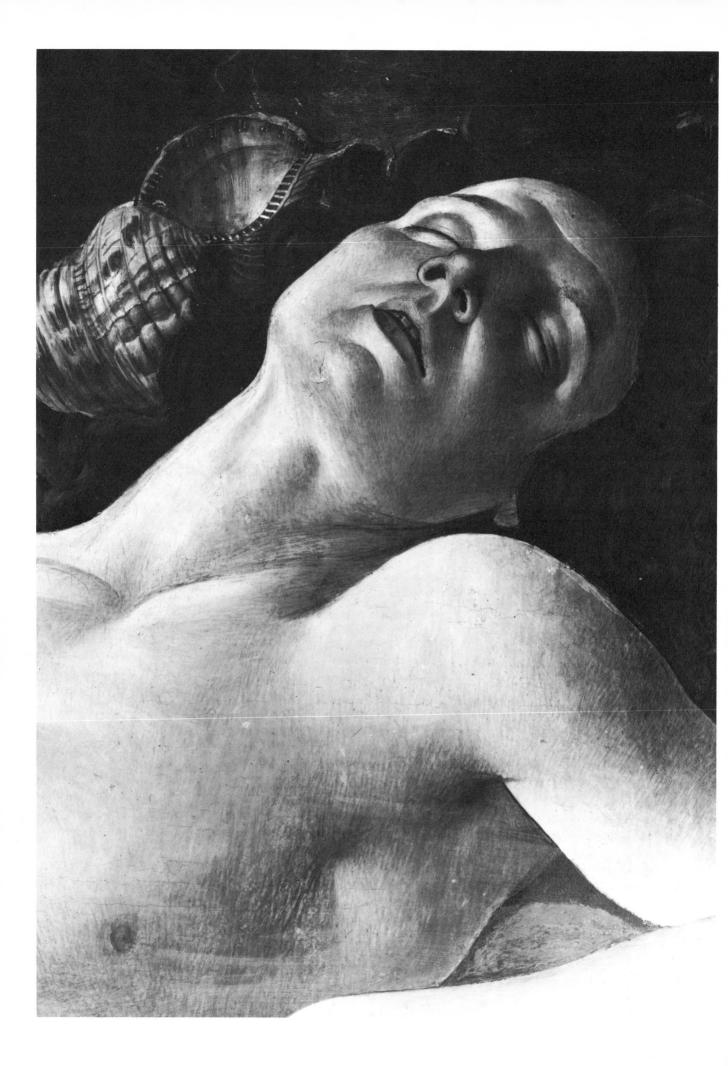

BOTTICELLI

SUSAN LEGOUIX

37640

ORESKO BOOKS LTD·LONDON

(frontispiece) Venus and Mars (detail of Plate 61)

ACKNOWLEDGEMENTS

I am especially grateful to Allan Braham of the National Gallery for making the Eastlake notebooks available to me and for his useful comments on the Merton portrait; Peter Dreyer of the Staatliche Museen, West Berlin; Christa Gardner; Martin Kemp of Glasgow University for generously allowing me to read his article on the Glasgow Annunciation prior to publication; Lady Merton for permission to reproduce the Portrait of a Young Man Holding a Medallion; Joyce Plesters of the National Gallery for information on Botticelli's technique and Christopher Wright for encouraging me to undertake the whole project.

Sincere thanks are also due to the following for their help in providing photographs and information: Accademia Carrara, Bergamo; Alte Pinakothek, Munich; Biblioteca Apostolica Vaticana, Vaticana City; Bildarchiv Preussischer Kulturbesitz, Berlin; British Museum, London; Capilla Real, Granada; City Art Gallery, Birmingham; Church of Sant' Anna dei Lombardi, Naples; Church of Santa Maria Novella, Florence; Fratelli Alinari, Florence; Gabinetto Fotografico Nazionale, Rome; Galleria degli Uffizi, Florence; Gallerie Nazionale di Capodimonte, Naples; Galleria Pallavicini-Rospigliosi, Rome; Isabella Stewart Gardner Museum, Boston; Glasgow Art Gallery, Glasgow; Metropolitan Museum of Art, New York; Monastery of Ognissanti, Florence; Musée du Louvre, Paris; Museo del' Opera del Duomo, Florence; Museo del Prado, Madrid; Museo Poldi-Pezzoli, Milan; National Gallery, London; National Gallery of Art, Washington; National Gallery of Scotland, Edinburgh; Oronoz S.A., Madrid; Philadelphia Museum of Art, Philadelphia; Pinacoteca Ambrosiana, Milan; Service de Documentation Photographique de la Réunion des Musées Nationaux, Paris; Staatliche Gemäldegalerie, Berlin; Staatliche Gemäldegalerie, Dresden.

For Ron

First published in Great Britain by Oresko Books Ltd., 30 Notting Hill Gate, London WII

UK ISBN 0 905368 18 5 (cloth) UK ISBN 0 905368 19 3 (paper) Copyright © Oresko Books Ltd. 1977

Printed in Great Britain by Burgess and Son (Abingdon) Ltd., Abingdon, Oxfordshire

Library of Congress Cataloguing in Publication Data

Legouix, Susan. Botticelli.

(Oresko art book series)

Bibliography: p.
1. Botticelli, Sandro, 1447?–1510. 2. Painters –
Italy – Biography. I. Botticelli, Sandro, 1447?–1510.
II. Title. III. Series.
ND623.B7L43 1977 759·5 77–10355
USA ISBN 0-8467-0376-9
USA ISBN 0-8467-0379-3 pbk.

Sandro Botticelli

This book illustrates over sixty paintings by Botticelli. Only one, *The Mystic Nativity* (Plate IV), is signed and dated, and only one group, the Sistine Chapel frescoes (Plates V and 30–36), is still in its original position. We know almost nothing about the life and character of the artist, and there is an awkward period of almost ten years at the end of his life when, for reasons as yet unknown, he seems to have abandoned painting altogether.

Such an accumulation of negative factors might be a deterrent to further investigation were it not for the magic of the images which survive. Botticelli's art has proved more magnetic to historians and critics during the past hundred years than that of any other fifteenth-century painter. Over forty serious studies have found a place on library shelves, and almost half as many picture books occupy the coffee tables and bookcases of the art lovers of the world.

The very high survival rate of Botticelli's work compensates for the lack of documentation. Sixty or so paintings, a collection of drawings and many associated studio works is a surprisingly large oeuvre for such an early master, and it enables us to make an assessment of his style which is likely to be far better balanced than our view of the work of a painter such as the ill-fated Mantegna who is represented today by only a tiny proportion of his original output.

The city of Florence and the quality of life it offered in the fifteenth century made Botticelli's work what it is. Florence was his birthplace and the town where he spent the whole of his life apart from a short visit to Pisa in 1474 and about a year spent in Rome from 1481-82. The Ognissanti region of Florence, where his family the Filipepi were tanners, was the centre of the wool-working industry. The Vespucci, near neighbours of the Filipepi and patrons of Botticelli, were most important in their own time as dealers in wool and silk, but are best remembered for the fact that Amerigo, one of their sons, gave a name to the New World. Their house and the one that Botticelli occupied for most of his life were in the Via del Porcellana which runs between Borgo Ognissanti and Via Palazzuolo (see map, pages 18–19). Vasari recounted a story which if it can be relied upon gives us a rare glimpse of Botticelli's character, and even if it is not altogether true does illustrate vividly the hazards of living amidst the busy fabric industry. A cloth weaver moved eight looms into the house next door to Botticelli's and so disturbed the artist with the deafening sound and vibration of his machines that work became impossible. Gaining no favourable response from his polite request for a little peace and quiet, Botticelli was finally driven to take desperate retaliatory action. On a high wall at the side of his house he balanced an enormous stone in such a position that at any suggestion of vibration it threatened to crash through the weaver's roof. The result was, according to Vasari, that the neighbour was forced to mend his ways and come to an amicable agreement with Botticelli.

Artists' workshops were themselves 'home industries' and by 1472 when Botticelli's name first appeared in the record books of the painters' guild he already had an assistant, the fifteen- or sixteen-year-old Filippino Lippi, son of Filippo Lippi who had died a few years earlier in 1469. By 1480 Botticelli's studio was firmly established and in a legal declaration of that year he listed three assistants, Raffaello di Lorenzo di Frosino Tosi, Giovanni di Benedetto Gianfanini and Jacopo di Domenico Papi. Elsewhere assistants named Jacopo, Biagio and Ludovico are mentioned, but the only one to emerge as an artist of individual talent was Filippino Lippi. Botticelli's own training in the 1460s appears to have taken place in the studio of Filippino's father Filippo Lippi. Certain features of his earliest pictures such as the architectural setting of the Madonna and Child in an Archway (Plate 2) and the Madonna and Child with Two Angels (Plate 3) can be seen to have been directly derived from models by Lippi, and Botticelli's sweet-faced women, so effusively praised in the literature of the early part of the twentieth century, are the natural descendants of Lippi's Madonnas and female saints.

In addition to Lippi the artists who made the most impression on the young painter were the Pollaiuolo brothers (fig. 1), with whom he worked in the hall of the Arte della Mercanzia (see Plate 6), and Verrocchio, the master of Leonardo. The influence of Verrocchio is most apparent in the early Madonna and Child pictures, such as those in the Uffizi (Plates 1 and 2), Naples (Plate 3) and Boston (Plate 4). These Madonnas wear robes and headdresses very similar to those of Verrocchio's Madonnas in the *Madonna and Child* in the

fig. 1 Antonio and Piero POLLAIUOLO Charity

Florence, Galleria degli Uffizi. Tempera on panel.

The Pollaiuolo brothers were responsible for paintings of the six Virtues, Faith, Hope, Charity, Temperence, Prudence and Justice, and Botticelli for the seventh, Fortitude, for the hall of the Arte della Mercanzia in Florence. It is generally believed that Piero Pollaiuolo painted Charity and the other panels, but scholars also believe that his brother Antonio had a hand in the designs of the figures. A comparison between this picture and Botticelli's Fortitude (Plate 6) shows how Botticelli imitated certain elements of the Pollaiuolo stylistic language, in particular the mannered treatment of hands and feet. Botticelli's figure, however, sits much more naturally on her throne than the Charity or any of the other Virtues.

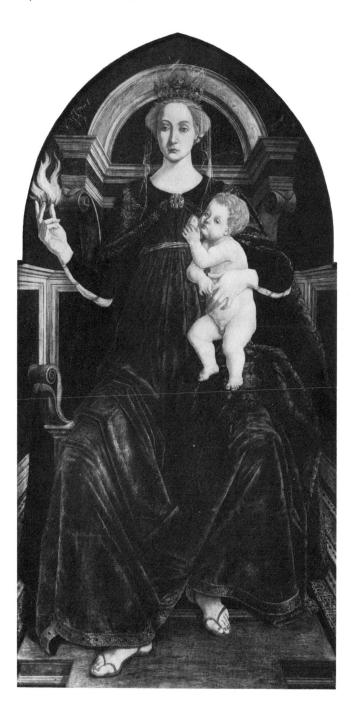

Staatliche Gemäldegalerie, Berlin (Dahlem) (fig. 2), and The Ruskin Madonna, now in the National Gallery of Scotland, Edinburgh (fig. 3). The facial features of the Madonnas in these pictures by Verrocchio and Botticelli are also strikingly alike. The relationship with Antonio and Piero Pollaiuolo is discernible mainly in the drawing of male figures and in the articulation of the limbs of figures in movement (fig. 4). The sinuous form of Holofernes in The Finding of the Dead Holofernes (Plate 54), which was probably painted around 1470, the period of the decorations in the hall of the Arte della Mercanzia, is reminiscent of nudes by Antonio Pollaiuolo, but by the time Botticelli painted the reclining Mars in Venus and Mars (Plate 61) in the late 1480s, the influence was no longer important. Similarities with Verrocchio also cease to be noticeable in the pictures of the 1480s although the pretty, feminine spirit of Lippi lingered and played a part in Botticelli's style until his latest period of the 1490s.

Filippo Lippi was lucky enough to be one of the generation of artists befriended and patronized by

fig. 2 Andrea del VERROCCHIO
Madonna·and Child
Berlin (Dahlem), Staatliche Gemäldegalerie.
Tempera on panel.

The Madonna in this picture and *The Ruskin Madonna* (fig. 3) are clearly related to early pictures by Botticelli such as the *Madonna and Child in an Archway* (Plate 2) and the *Madonna and Child with Symbols of the Eucharist* (Plate 4).

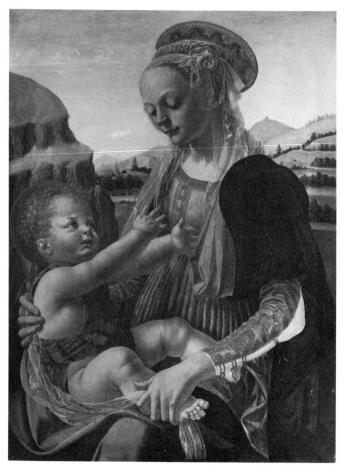

Cosimo 'il Vecchio' de' Medici, and Botticelli had equal good fortune in that his coming of age as a painter coincided with the assumption of Cosimo's grandson, Lorenzo 'il Magnifico', to the leadership of the Medici family and its party on the death of his father, Piero 'the Gouty', in 1469. It is not known precisely how much work Botticelli executed for the Palazzo Medici in Florence, but an inventory made at the time of Lorenzo's death in 1492 records a Fortuna and a standard decorated with a Pallas made for a famous tournament organized by the Medici in the Piazza Santa Croce in 1475. In addition, Vasari mentioned portraits of Lucrezia Tornabuoni, mother of Lorenzo de' Medici, and of Simonetta Vespucci and a Bacchus, all hanging in various parts of the Palazzo Medici. Like the decorative frescoes painted for the Medici family at their country villas of Spedaletto, near Volterra, and Castello, just outside Florence, these works are all lost. Happily three major paintings commissioned by Lorenzo's second cousin Lorenzo di Pierfrancesco de' Medici do survive, Pallas and the Centaur (Plate 63), Primavera (Plate 65) and The Birth of Venus (Plate 66). All three are believed to have been executed for the Villa di Castello. They were only removed from there and seen for the first time by the public in the nineteenth century. Botticelli's relationship with Lorenzo di Pierfrancesco appears to have been very close. In 1496 when the Medici administration was on the point of collapse and any written communication to the family was in danger of being intercepted by political opponents, Michelangelo despatched a letter to Lorenzo di Pierfrancesco addressed to 'Sandro di botticello in firenze'. The trust between this member of the Medici

fig. 3 Andrea del VERROCCHIO
Madonna and Child (The Ruskin Madonna)
Edinburgh, National Gallery of Scotland.
Tempera transferred from panel to canvas.

Although this picture is very closely related to other Madonna and Child groups attributed to Verrocchio, it has also been proposed that it might be an early work of Leonardo da Vinci executed in Verrocchio's workshop.

fig. 4 Antonio POLLAIUOLO
Battle of Nude Men
London, Victoria and Albert Museum
(Department of Prints and Drawings).
Engraving.

Although Botticelli's early development reflected the influence of Pollaiuolo the nudes in this 'battle' illustrate an obsessive interest in dynamic movement which is very different from the grace of, for instance, Botticelli's *St. Sebastian* (Plate 7).

family and Botticelli was of particular importance as it gave the artist the freedom he required to produce his most original and extraordinary work, the illustrated *Divina Commedia* (Plates 70–73).

Although the two pictures most familiar today, *Primavera* and *The Birth of Venus*, were Medici commissions, most of Botticelli's time and energy was devoted to working for the Church, as can be seen from a glance at the map of Florence on pages 18–19 illustrating the original distribution of the pictures in the city. As Botticelli undertook no multiple-panel altar pieces there are practically no reconstructions of altar pieces or fresco cycles to be made and historians have tended

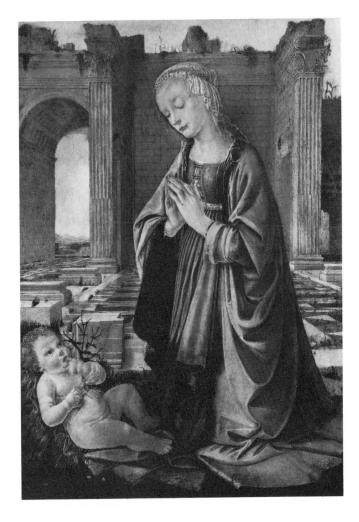

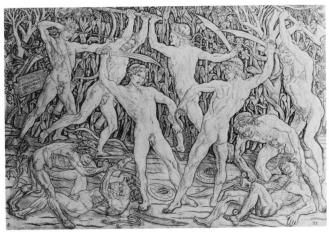

to pay little attention to the sites in Florence for which many of the pictures were painted, though on occasions they may have a bearing on the final appearance of the work. The Berlin St. Sebastian (Plate 7) is an interesting case. It hung originally, we are told, 'in una colonna' in the Church of Santa Maria Maggiore, and the deduction that the picture is tall and narrow because it hung on a pillar, though fundamental, is only one of the conclusions which follows. Santa Maria Maggiore is a three-aisled hall, one of the oldest churches in Florence, supported by solid quadrangular piers which measure 87.5 cm. in width at eye level. The first column on the right is frescoed with two tiers of full-length saints, probably executed by two or more different fourteenthcentury artists. The lower tier of the east face of this pier is occupied by an Execution of St. Sebastian. Since representations of archers as well as of the saint himself had to be fitted into the limited space, the individual figure of St. Sebastian is half the size of the other seven saints decorating this column. The composition is crowded and uncomfortably out of scale with the other figures, and it is quite feasible that Botticelli's own recognition of the shortcomings of this earlier painting led him to make his St. Sebastian for the same church a single figure composition. It is even possible that Botticelli's panel was made to hang over the fresco, but as yet no record has been found of who commissioned his painting.

The Bardi Altarpiece (Plate 9) of 1485, now in Berlin, is another picture which may have been influenced by the nature of its original location. It occupied the first altar on the left on the back wall of the chancel in Santo Spirito. There is not a great deal of evidence that Botticelli was an artist particularly sensitive to the fall of light, but the direction of the light source in the Bardi Chapel does coincide with that in the picture. What may be more significant is the architecture, or lack of architecture, in the composition. Brunelleschi's Santo Spirito was one of the great new churches of Florence, a model for architects of Botticelli's generation. Rather than compete with Brunelleschi and place his figures in their own architectural setting, as did, for example, Cosimo Roselli in his Madonna Enthroned of 1482 nearby in the transept, Botticelli constructed rich leafy arches which serve the function of architecture in framing and setting off the figures, but which bear no relation to any building style. There is every indication that the picture is one of the most painstakingly composed and executed of the artist's works and so it is not altogether surprising to learn that the frame, now lost, was made by Giuliano da Sangallo, the eminent architect who only a few years later was working on the fabric of Santo Spirito, building the sacristy. A tondo still furnished with an original frame, The Virgin and Child with St. John and an Angel (fig. 5) in London, is inscribed on the back [M?]Giuljano da san Ghallo, which may signify another case of collaboration between the two artists.

For making the frame of The Bardi Altarpiece Sangallo received almost a third as much as Botticelli was paid for painting the picture. But these figures are misleading unless examined in more detail. Of Botticelli's seventyeight florins, thirty-eight were for the gold and gilding of the altarpiece, and of Sangallo's twenty-four florins a fair proportion must have been spent on materials. What emerges from the figures is the high price paid for embellishments. Of a total of 102 florins paid by Agnolo Bardi for the altarpiece only thirty-five florins went towards the artist's brushwork. The picture would not of course have been the same without the embellishments. The decorative character of Botticelli's art has always been recognized as one of its greatest qualities, though in the present century a preoccupation with iconographical questions has tended to override considerations of the glory of ornamentation. The astute Herbert Horne, whose monograph on Botticelli is an essential point of departure for all later studies, observed that in nineteenth-century England 'The pictures of Botticelli and his school, like those of Crivelli, were sought out for their decorative beauty before their finer and more artistic traits had been duly appreciated, or even realised.'

Horne's coupling of the names of Botticelli and Crivelli is not merely fortuitous. Subconsciously he pinpointed a deeper truth about the place of Botticelli in history. In an age when we are conditioned to search for historical and artistic developments, it is disturbingly difficult to accommodate neatly the work of Crivelli and Botticelli. Both occupy their own private culs-de-sac. By the end of Crivelli's life Titian was almost ten years old and by Botticelli's death in 1510 Raphael was working on the Stanze of the Vatican and Michelangelo on the ceiling of the Sistine Chapel. If few pictures survived by Crivelli or Botticelli we could be forgiven for imagining that Crivelli might have worked towards a style which looked finally something like that of the early Titian, and that Botticelli's late work looked rather Raphaelesque. Yet the reality is that if any of Botticelli's work looks remotely Raphaelesque it is that of his middle rather than of his late period, and that the passage of time sees his art and that of Crivelli move into a distinctly Gothic idiom.

If it is true of any artist it is true of Botticelli that his art was a personal statement. It can be enjoyed for its own sake regardless of its place in any pattern of development which historians with hindsight project as to the period and style to which it belongs. Yet doggedly we pursue the quest for a wider significance, with varying degrees of success depending on our interpretive skills. Wölfflin, whose particular objective was 'classic' art, wrote: 'He [Botticelli] succeeds in imparting this flowing line to his large masses, and where he orders his picture in a unified composition around one centre something specifically new is created, the consequences of which are of great importance. It is in this sense that

his compositions of *The Adoration of the Magi* are to be considered.' It may not be especially helpful to seek out these 'consequences', but an examination and comparison of the five surviving Adoration and Nativity pictures does reveal many of the nuances of Botticelli's personal style over the thirty-year period of his working

fig. 5 Studio of BOTTICELLI

The Virgin and Child with St. John and an Angel
London, National Gallery. Tempera on panel.
Original frame.

Although this is generally acknowledged today to be a studio piece it is a most appealing picture, competently executed. Similar shiny haloes appear in a *Madonna and Child Embraced by St. John* in the Pitti Palace, Florence, which may be by the same hand.

life. Visitors to London are fortunate enough to be able to see three of these five pictures hanging in the same room in the National Gallery. The remaining two are in the Uffizi, Florence, and the National Gallery of Art, Washington.

The earliest of the Adorations is the small but wide panel in London (Plate 17). The Virgin and Child are placed to one side of the picture and a huge crowd of figures led by the Magi stream away from them. The scheme is much the same as that used by Gentile da Fabriano as early as 1423 in his famous Adoration of the Magi now in the Uffizi (fig. 6). Like Gentile, Botticelli made his first king kneel to kiss the toe of Christ and the second kneel and remove his crown. The figure style adopted by Botticelli in the picture is very close to that

fig. 6 Gentile da fabriano
The Adoration of the Magi
Florence, Galleria degli Uffizi. Tempera on panel.

This glorious altarpiece would have been seen by Botticelli in the Strozzi Chapel in Santa Trinità, Florence, where it originally hung.

fig. 7 Studio of BOTTICELLI
The Holy Family
Boston, Isabella Stewart Gardner Museum.
Tempera on panel.

This picture is composed of a curious patchwork of styles, and it has even been suggested that the massive St. Joseph is the work of the young Michelangelo.

of Lippi, so close that many scholars agree with Horne that this is 'one very early painting' by the artist, probably done soon after he left his master's studio. The highly experimental nature of the technique, apparent in the numerous revisions of certain areas of *The Adoration*, and the struggle which has gone into the depiction of the architecture are additional signs of immaturity, but the picture could not be called incompetent. The characterization of the figures is remarkably varied and expressive. Two young shepherds who make a speedy entry on the right are related to a pair who appear with rather less verve in a much

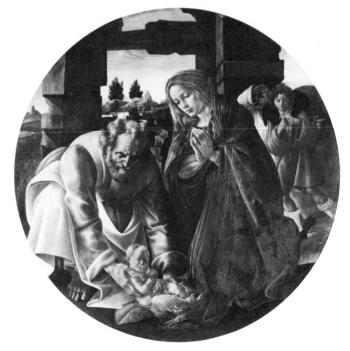

later studio picture in the Isabella Stewart Gardner Museum, Boston (fig. 7). Their origin is mysterious. Mantegna introduced a similar but more uncouth pair on the right-hand side of his *Adoration of the Shepherds* of about 1450 in the Metropolitan Museum, New York

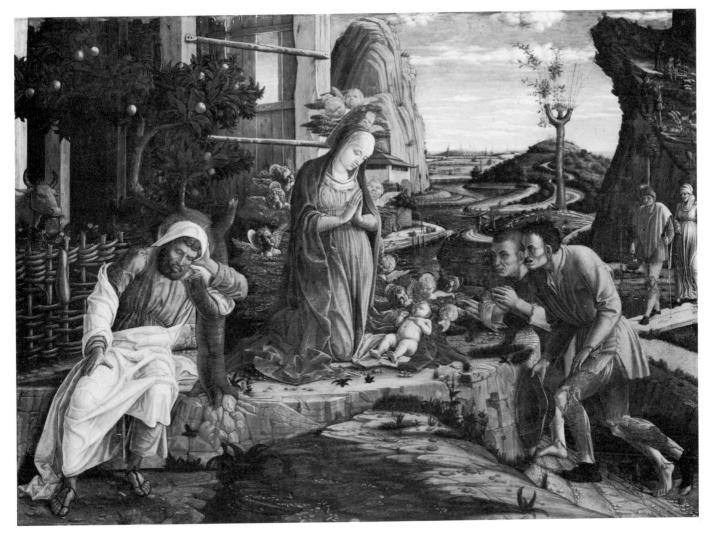

fig. 8 Andrea Mantegna
The Adoration of the Shepherds
New York, Metropolitan Museum of Art.
Tempera transferred from panel to canvas.

fig. 9 Antonio ROSELLINO
The Nativity
Naples, Church of Sant' Anna dei Lombardi.
Marble relief.

Antonio Rosellino carved this relief in the 1470s as the altarpiece for the tomb chapel of Maria of Aragón in the Church of Sant' Anna dei Lombardi. The work was carried out in Florence and then transported to Naples. It has been suggested that the shepherds could have been influenced by Hugo van der Goes's Portinari Altarpiece, but it is now known that this did not arrive in Florence until 1483, after Rosellino's death.

(fig. 8), as did Antonio Rosellino in his relief *Nativity* in Naples (fig. 9) of the 1470s.

The tondo Adoration of the Magi in London (Plate III) repeats a number of the figures from the first picture, such as the man to the extreme left who blows his nose, but it is certainly a work of greater maturity. The success of the composition can only be fully realized if it is placed against an earlier circular Adoration such as that by Filippo Lippi in the National Gallery of Art, Washington (fig. 10). Whereas Lippi simply condensed the traditional rectangular grouping, Botticelli moved

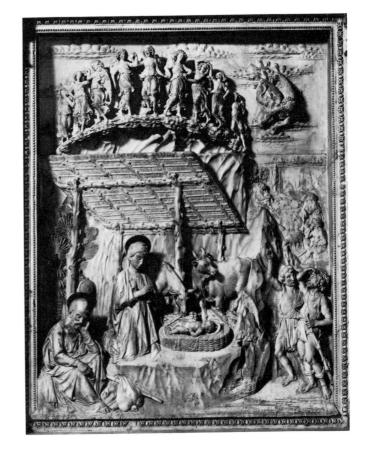

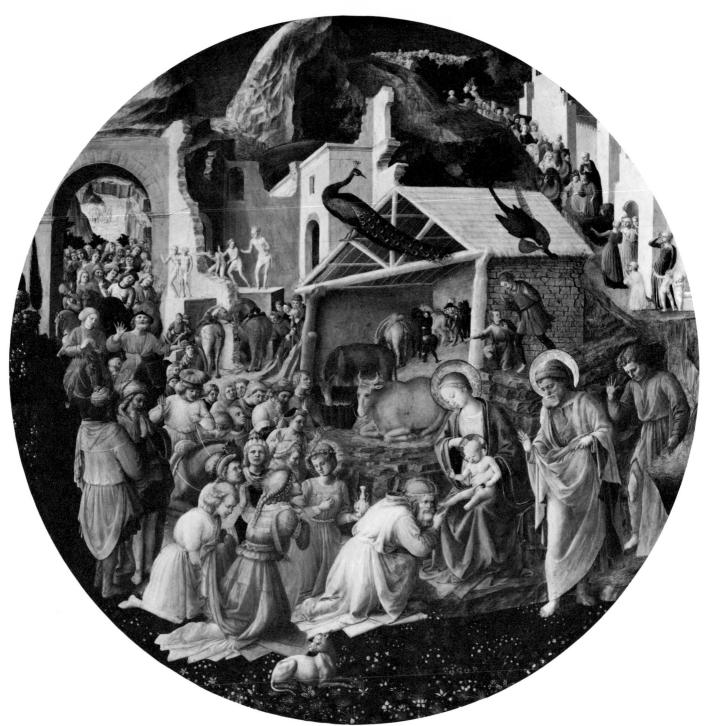

fig. 10 Filippo LIPPI
The Adoration of the Magi
Washington, National Gallery of Art (Samuel
H. Kress collection). Tempera on panel.

This picture of about 1445 is an early, if not the earliest, tondo Adoration composition. It is thought to have been conceived and perhaps partially executed by Fra Angelico and completed by Filippo Lippi. It is not known where in Florence it originally hung.

the Virgin right back into the centre of the circle and allowed her to be smaller than the foreground members of the crowd. Attention is skilfully focused on her by the grouping of the surrounding figures and by the arrangement of the monumental ruined architecture which soars above.

The figures in the third Adoration of the Magi (Plate 21) in the Uffizi are much larger in scale than those in the two London pictures, but even so they must have been dwarfed by the vast interior of Santa Maria Novella where the picture originally was. Vasari called it 'a truly admirable work, executed so beautifully, in colouring, drawing, and composition, that every craftsman today marvels at it'. He pointed out that most of the figures in the picture are portraits of the Medici family and their entourage. It must have been the call for portraits in the commission, in addition to the size of the church, which dictated the scale of the figures. In order to represent each person as clearly as possible Botticelli not only made each larger than his counterpart in the London pictures, but he also placed the

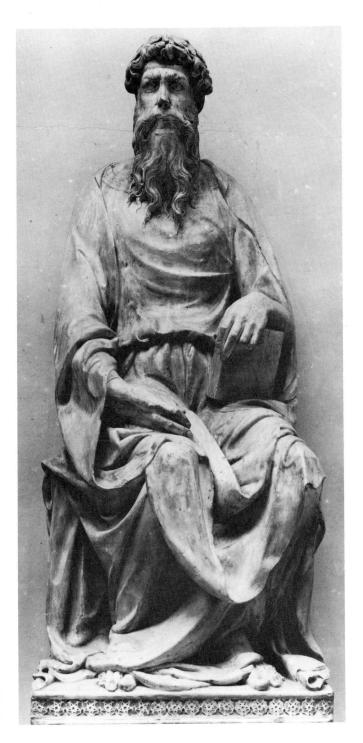

fig. 11 DONATELLO
St. John the Evangelist
Florence, Museo del' Opera del Duomo.
Marble.

A drawing by a Florentine artist of the second half of the sixteenth century in the Museo del' Opera del Duomo shows sculptures of the four Evangelists flanking the great west door of Florence Cathedral. Donatello's *St. John* was on the right-hand side nearest the door.

group on a slight slope so that the heads could be seen above each other. This picture was painted around 1475–77, perhaps only five or six years after the London tondo. The increase of naturalism in Botticelli's style during this period can be demonstrated by a comparison of the horse's head on the left of the composition

(Plate 22) with horses in the London pictures. Instead of being a formalized creature apparently drawn from Antique sculpture, the horse in the Uffizi Adoration is a tactile quivering beast who nuzzles at the arm of his owner. The Madonna presenting her child to the oldest king, a portrait of Cosimo de' Medici, differs very little from the earlier representations of her. Her curiously extended torso suggests that Botticelli might have used sculptural models such as Donatello's St. John (fig. 11) for studies of seated figures. It is usually supposed that the St. John was deliberately made very tall so that in his original position on the façade of the Duomo the figure appeared in proportion when seen from the ground. But Donatello surely over-compensated, for the St. John sat in the lowest row of niches, and if an artist were to place himself at a comfortable distance to draw the sculpture he would have seen a figure with an exaggeratedly tall body and short legs, rather like Botticelli's seated Madonnas.

Vasari said of the Uffizi Adoration that it brought Botticelli considerable fame, both in Florence and further afield and led to the call to Rome to work in the Sistine Chapel. The fourth of the known Adoration pictures, the one now in Washington (Plate 23), is thought to have been executed in Rome and it represents a turning point in Botticelli's approach to the subject and perhaps in his whole career. It is in many respects the least 'Botticellian' and the most classical of his Adorations. Significantly, it is probably the picture Wölfflin had in mind when he spoke of Botticelli's creation of 'a unified composition around one centre'. Critics have often commented that the picture shows the influence of Perugino and Signorelli whom Botticelli met while working in the Sistine Chapel. The influence could have been through one specific composition, The Nativity fresco by Perugino which, until Michelangelo obliterated it with his Last Judgement, occupied the right-hand side of the altar wall of the chapel (see diagram, p. 54). It is unlikely that Signorelli arrived in Rome until after Botticelli and the other artists left, so the suggestion of his influence can be safely discounted. There is unfortunately no record of the appearance of Perugino's composition, but it could easily have been set in a landscape similar to the one in Botticelli's picture and it might have had a 'stable' with a heavy king-post roof on a row of sharply receding columns like the one in the Washington Adoration. Features of architecture and landscape related to this Adoration occur in other pictures by Perugino.

Botticelli's classical 'Peruginesque' period lasted throughout the 1480s and probably culminated in *The Coronation of the Virgin* (Plate 15), after which the very personal style of the *Divina Commedia* illustrations (Plates 70–73) and *The Mystic Nativity* (Plate IV) gradually emerged. Although not illustrated in this book because of their damaged and incomplete state, there exist fragments of two further Adoration of the Magi

pictures which appear to be developments of the Washington composition and which are in the possession of the Soprintendenza alle Gallerie, Florence, the Pierpont Morgan Library, New York and the Fitzwilliam Museum, Cambridge, the last two being elements of one picture.

If it were possible to hang the Washington Adoration of the Magi next to the London Mystic Nativity viewers unfamiliar with the work of Botticelli might justifiably find it hard to believe that both pictures were by the same hand. The artist's latest style is most perfectly exemplified in The Mystic Nativity of 1500-01. The following passage was written by John Addington Symonds about Fra Angelico, but it translates into words a spirit so close to that of the late Botticelli, and The Mystic Nativity in particular, that I quote it in full: 'His world is a strange one—a world not of hills and fields and flowers and men of flesh and blood, but one where people are embodied ecstasies, the colours tints from evening clouds or apocalyptic jewels, the scenery a flood of light or a background of illuminated gold. His mystic gardens, where ransomed souls embrace, and dance with angels on the lawns outside the City of the Lamb, are such as were never trodden by the foot of man in any paradise of earth.' Botticelli may have been remembering Fra Angelico's Last Judgement in San Marco when he drew the foreground figures in The Mystic Nativity, and the dancing angels in the sky recall those in Rosellino's Nativity (fig. 9) but the style of the painting is outside most fifteenth-century terms of reference. He returned to the Gothic principle whereby the most important character in a composition was the largest in scale, and he abandoned modern architecture and scientific perspective in favour of a rural setting in which natural rock appears to have erupted from the shifting earth's crust in order to frame and protect the Holy Family. In many ways the picture is a synthesis of old and new in Botticelli's art. It is archaic in iconography and in the extensive use of gold, which underlies the whole of the thatch roof, the upper part of the sky and the dancing angels, but it is new in that it appears to have been executed in oil on canvas rather than Botticelli's usual tempera on panel, and in that it seems likely that it was painted purely as a vehicle for self-expression. The concept of 'art for art's sake' is more often associated with the sixteenth century and the Mannerist movement than with the late quattrocento, but the fact that The Mystic Nativity so unashamedly fails to meet the requirements of spatial realism and naturalism of an up-to-date picture of 1500 almost certainly precludes it from being a commission for public view.

A poignantly beautiful picture which is stylistically very close to *The Mystic Nativity* is the Granada *Agony in the Garden* (Plate 24), which was a commission but was destined for a site well away from the Florentine avant-garde. The composition differs little in essentials

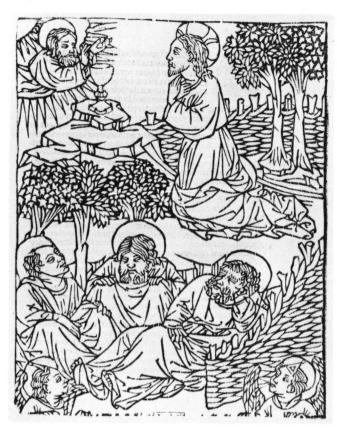

fig. 12 Venetian, c. 1450 The Agony in the Garden New York, Metropolitan Museum of Art (Harris Brisbane Dick fund). Woodcut.

This is one of the scenes from Bonaventura's *Meditatione sopra la Passione*, printed in 1487, which re-used illustrations from the Venetian block-book, *Passion of Our Lord*, of c. 1450.

from an anonymous woodcut illustration of the same subject (fig. 12) made at least half a century earlier. Again Botticelli found the style of an earlier period more appropriate to his expressive need than that of his own time.

Also closely akin to The Mystic Nativity in its nonrealistic approach is the illustrated Divina Commedia (Plates 70-73). Herbert Read in The Art of Sculpture wrote: 'The theory of perspective developed in the fifteenth century is a scientific convention; it is merely one way of describing space and has no absolute validity'. Botticelli treated the theory as if it had no validity whatsoever in the Dante drawings. Through the cantos of the Inferno, Purgatorio and Paradiso he turned art and the world upside down. In episode after episode fierce curling flames pour out of the ground and sometimes out of half-open tilted rhomboid tombs, and figures gnaw at each others' and their own flesh in a world of sharp-edged rocks, deep caverns and vicious thorny woods. Gradually, the scenes become calmer and emptier of figures, and Dante is transported into a state of purity and joy which is Paradiso.

The intensity of these drawings and the latest paintings is often associated with the puritanizing cult of Fra Girolamo Savonarola of San Marco whose emotional

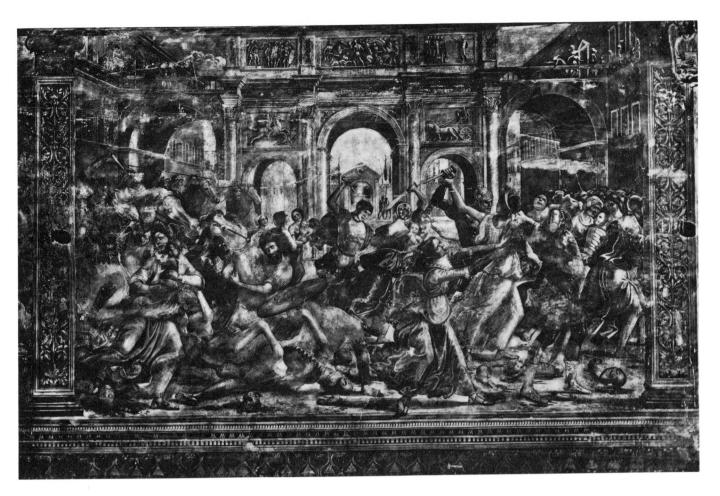

fig. 13 Domenico Ghirlandaio
The Massacre of the Innocents
Florence, Church of Santa Maria Novella.
Fresco.

Ghirlandaio worked beside Botticelli in Ognissanti and in the Sistine Chapel in Rome. His fresco cycle in the choir of Santa Maria Novella was completed in 1490.

rallying sermons finally led to political revolution and his own execution in Florence in 1498. It is not entirely clear how closely Botticelli was involved with the monk's near-hysterical form of religion. Vasari claims he became so ardent a follower that he gave up working and spent his last years in poverty and distress, but one of the few surviving documents concerning Botticelli's old age does not endorse this view. In 1502 the agent of the great patron of the arts Isabella d'Este, Marchioness of Mantua, a demanding lady who did not take kindly to emotional or capricious artists, wrote to his employer, 'Botticelli has been much extolled to me both as an excellent painter and as a man who works willingly . . . ' This, written four years after Savonarola's death, does not seem like a description of a man whose head was turned by extremist religious fervour. Two years later Botticelli was one of the committee chosen to decide on a site for Michelangelo's David, which again indicates that he must still have been regarded as a man of stature in Florentine society.

One of the great qualities of Botticelli's *Divina Commedia* illustrations is the clarity of the narrative. As

the scenes flow from page to page the forms of Dante and Virgil can always be easily identified and their gestures and expressions quickly interpreted. The experience of working in the Sistine Chapel (Plates V and 30-36), where Botticelli had the more difficult task of being one of an artistic team creating a continuous theme, must have sharpened his sense of narrative. Some of his compositional arrangements in the Sistine frescoes were indeed more successful in this respect than those of other painters working in the chapel who, unlike Botticelli, had had the advantage of previous practice of fresco cycle painting. Agostino Taja's mideighteenth-century guide to the Vatican singled out Botticelli's Punishment of the Rebels (Plate V) as being especially praiseworthy. In this painting, more than in the other two which Botticelli painted for the Sistine Chapel, the background and surrounding architecture were manipulated to organize and punctuate the narrative. A centrally-placed arch is not an unusual feature in fifteenth-century compositions, Gozzoli used one in his Jacob and Esau which Botticelli could have seen in the Camposanto at Pisa, but its effectiveness in The Punishment of the Rebels is striking and may have inspired Ghirlandaio, one of the Sistine artists, when he painted his Massacre of the Innocents (fig. 13) in Santa Maria Novella.

Narrative is again the keynote of one of Botticelli's small mythological paintings, *The 'Calumny' of Apelles* (Plate 64) now in the Uffizi. The picture is literally

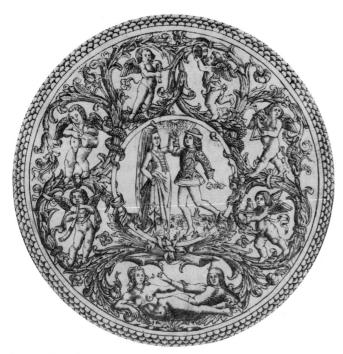

fig. 14 Baccio BALDINI
Pair of Dancers in a Wreath with Cupids
London, British Museum, Department of
Prints and Drawings. Engraving.

Vasari recounted that Baccio Baldini was the engraver of Botticelli's designs for the 1481 edition of *La Divina Commedia* (Plates 70–73). This *Pair of Dancers* of c. 1475 is one of the 'Otto Prints', a series of hunting and amorous scenes intended to be pasted into gift boxes.

composed from two or more written descriptions of the Calumny painted in the fourth century B.C. by the Greek artist Apelles. Perhaps with this picture subconsciously in his mind, Ruskin called Botticelli a 'reanimate Greek', and even before The 'Calumny' of Apelles had been painted a writer contemporary with Botticelli, Ugolino Verino, had called him 'the successor of Apelles'. Botticelli's connection with the Antique was usually less direct than in The 'Calumny' of Apelles and is generally far less easily understood. Although the majority of scholars now agree on the identification of the principal allegorical figures in The Birth of Venus (Plate 66) and the Primavera (Plate 65), neither picture illustrates an existing text as closely as The 'Calumny' follows Lucian's and Alberti's description of Apelles's painting.

The mythological pictures are set apart from the Christian Adorations, Annunciations and Madonnas as a result of the complexity and unfamiliarity of their subject matter and because they reveal Botticelli as a compositional innovator. Visual models for classical themes were few and far between in the quattrocento. Botticelli's solution was to adapt and transform suitable existing images with such skill and artistry that he appears to have created something absolutely new. No obvious model for *Venus and Mars* (Plate 61) can be found in panel painting of the period, but lovers are sometimes depicted reclining opposite each other in

small scale decorative and engraved works of art, and a seemingly insignificant detail such as the border of Baccio Baldini's *Pair of Dancers* (fig. 14) could have been the sort of image which provided the foundation for Botticelli's composition. It is possible that some Flemish tapestry may have inspired the strongly two-dimensional structure of the *Primavera* and, as Gombrich has suggested, the traditional arrangement of the Baptism of Christ may be the origin of the composition of his *Birth of Venus*.

The three Graces of the Primavera are loosely based on a classical sculpture group, such as one in the Libreria Piccolomini, Siena, but unlike the classical sculptor, and also unlike Raphael later on, Botticelli chose to make his Graces move. They are usually said to be dancing, but it might equally be said that their bodies are simply infused with a spirit of movement. Botticelli was not, as was Leonardo, interested in dynamics, and he introduced movement as a means of creating flowing linear compositions or as an expression of narrative content, but never in the interest of depicting the muscularity of the human body in action. Botticelli's figures are incapable of ever being entirely static. This is demonstrated by the comparison of one of Botticelli's 'still' figures, the St. John the Baptist of The Bardi Altarpiece (Plate 9), with an earlier monumental depiction of the same saint in the same attitude by Domenico Veneziano (fig. 15).

We know from the composition of The 'Calumny' of Apelles that Botticelli had read Alberti's De Pictura. This treatise also contains some advice on movement which is graphically reflected in the Primavera and The Birth of Venus: 'it will be a good idea, when we wish clothing to have movement, to have in the corner of the picture the face of the West or South wind blowing between clouds and moving all the clothing before it. The pleasing result will be that those sides of the bodies the wind strikes will appear under the covering of the clothes almost as if they were naked, since the clothes are made to adhere to the body by the force of the wind . . .' On hair Alberti wrote, 'let it twist around as if to tie itself in a knot, and wave upwards in the air like flames, let it weave beneath other hair and sometimes lift on one side and another'. The hair of Venus in The Birth of Venus was created almost as if by Alberti's command.

Although the words of Alberti on movement fit Botticelli's images so well that we cannot fail to associate the two, the artist never allowed himself to be bound by rules. Unpredictability is a characteristic of his art. In La Divina Commedia, Inferno, Canto XXXII Botticelli drew Dante with two heads in order to express the turning movement which follows the shifting of the poet's attention from one subject to another. The lack of respect for accepted artistic convention which Botticelli displayed on occasion can easily confuse the historian whose job it is to unravel the meaning of the images. The two-headed Dante is unlikely to be mis-

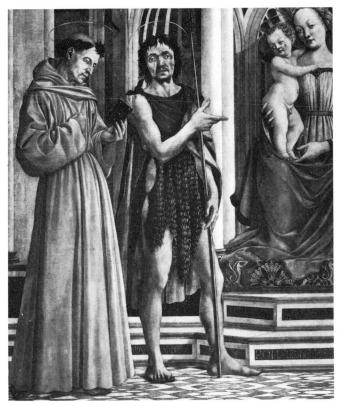

fig. 15 Domenico VENEZIANO

Madonna and Child with Saints, detail of
St. John

Florence, Galleria degli Uffizi. Tempera on panel.

The picture was painted for the Church of Santa Lucia de' Magnoli in Florence in the mid-1440s. It is often referred to as *The St. Lucy Altarpiece*.

fig. 16 Miniature figures of Botticelli's Venus, cast in alabaster powder or some other compound, are found not only in Italian gift shops. In a shop in Kent they jostle with Rodin's The Kiss and the Venus de Milo.

understood in the context of a series, but in the large mythological paintings, which have no continuous narrative content, the borderline between what is meant to be pure representation and what is 'artistic licence' is more subtle. In *The Birth of Venus* the two figures flying in from the left propelling Venus towards the shore are usually taken to be zephyrs, but the author of a fairly recent reappraisal of the picture calls the

female figure Chloris, the earth nymph, because in his opinion she is not blowing and has no wings. In fact it is clear from the original picture that a stream of breath or wind is issuing from her lips and she does have wings. There are four wings behind the entwined figures, and although the two wings behind the woman do not appear to be attached to her anatomically correctly, why should something that is in essence 'unreal', as figures do not have wings, be painted in a 'real' way? Botticelli no doubt felt that it was quite sufficient to state that four wings shared out between two people meant two wings each. This kind of visual shorthand is carried right through The Birth of Venus. The waves from which Venus has risen are, as Yashiro, the most inspired of Botticelli's biographers, observed, 'as unreal as they can be'. They appear as a pattern of white 'V' shapes on a flat ground of light greenish-blue which makes little attempt to suggest the transparency and wetness of water. The tree trunks too, on the right, are stiff brown columns which are more akin to architecture than to nature, and their unreality is heightened, as if that were necessary, by a strip of gold applied in short regular strokes down one side of each trunk.

The combination of esoteric subject matter and bold and fluent design which caused certain nineteenthcentury authors to shy away from The Birth of Venus also made the picture, conversely, one of the most popular images in Italian art in the twentieth century. In Crowe and Cavalcaselle's History of Italian Painting (1911) the only comment on the style of the painting is 'The figures are a little out of balance'. Today the figure of Venus in particular is so well loved that it has even been translated into three-dimensional form for mass sale in Britain and abroad (fig. 16) and is so familiar that a large proportion of the viewers of BBC television's Monty Python's Flying Circus could be expected to recognize her when, seen on the screen as a cut-out with articulated legs, she performed a variation of the Charleston on the edge of her shell. The Birth of Venus above all other of Botticelli's paintings has 'stage presence'. Kenneth Clark recalls its dramatic entrance to the famous 1930 exhibition of Italian art at Burlington House, London. 'With my love of coups de théâtre I asked the Academy attendants to keep Botticelli's Birth of Venus on one side until I could collect everyone working on the hanging to watch her rise from the basement into the gallery; and it was an unforgettable moment.' Lord Clark had seen the picture many times before, but viewing it in different surroundings and, literally, from an unusual angle, he experienced its impact anew. For those of us who have to make a fresh presentation of Botticelli's pictures in words and photographs alone the task is more difficult. We can only ask, as Walter Pater did in 1870, 'What is the peculiar sensation, what is the peculiar quality of pleasure, which his work has the property of exciting in us, and which we cannot get elsewhere?'

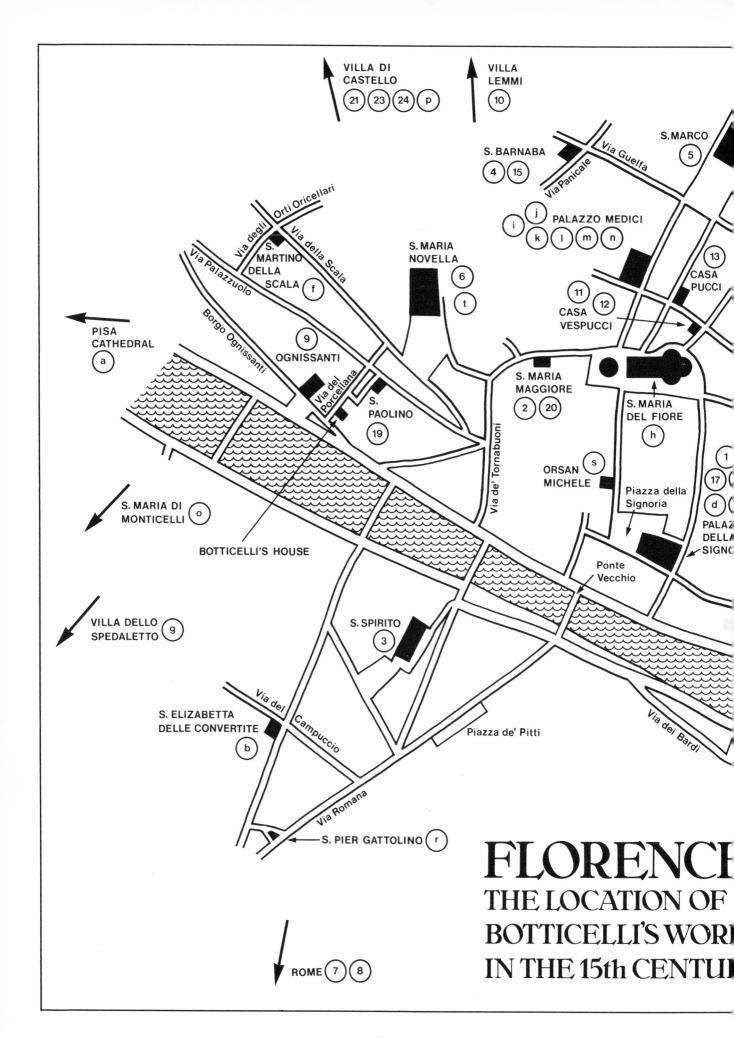

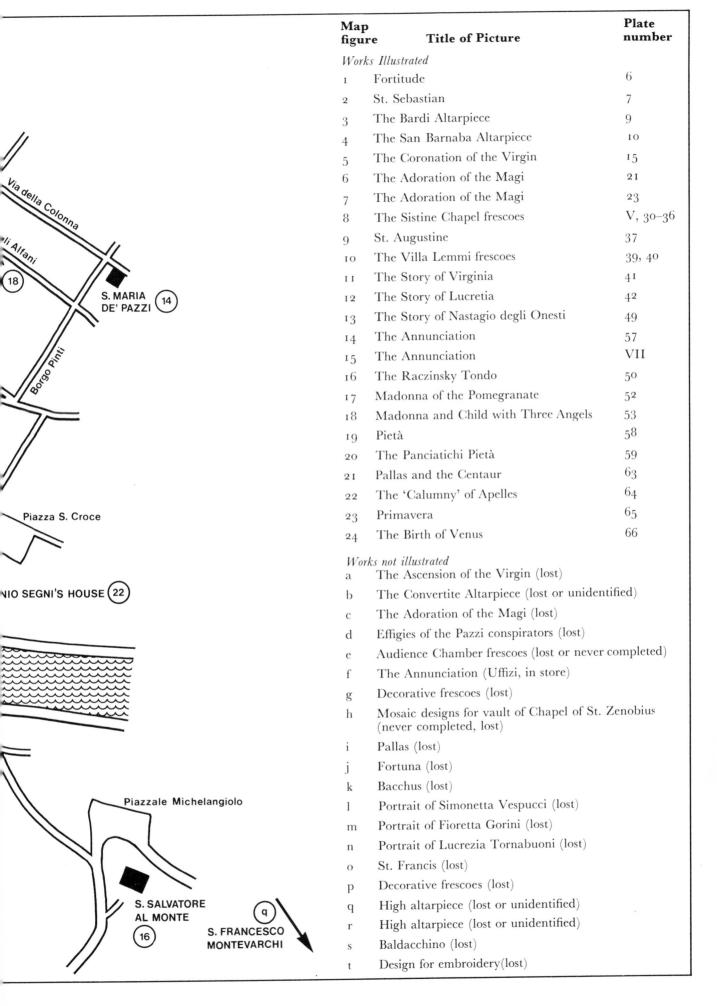

Chronology

	Documented Events	Approximate Chronological Sequence of Pictures
1445	Birth of Alessandro Filipepi, later known as Botticelli, in Florence.	
1467	Filippo Lippi left Florence for Spoleto; Botticelli is believed to have been in his workshop before this date.	
1467-70		Madonna and Child in a Mandorla of Seraphim (Plate 1); Madonna and Child in an Archway (Plate 2); Madonna and Child with Two Angels (Plate 3); The Adoration of the Magi (Plate 17)
1470	The Pollaiuolo brothers and Botticelli painted Virtues for the hall of the Arte della Mercanzia.	Fortitude (Plate 6); The Finding of the Dead Holofernes (Plate 54); The Return of Judith (Plate 55); Madonna and Child with an Angel with Symbols of the Eucharist (Plate 4)
1472	Filippino Lippi was working as an assistant to Botticelli.	Madonna and Child Enthroned with Six Saints (Plate 8); The Adoration of the Magi (Plate III)
1474	Botticelli went to Pisa (27 January).	St. Sebastian (Plate 7); The Adoration of the Magi (Plate 21); The Raczinsky Tondo (Plate 50)
1478	The Pazzi conspiracy (26 April); Botticelli commissioned to portray the hanged criminals in fresco on the wall of the Palazzo Vecchio.	Primavera (Plate 65); Abundance (Plate 69); St. Augustine (Plate 37); The Annunciation (Plate 56)
1481-82	Botticelli worked in Rome.	The Sistine Chapel frescoes (Plates V and 30–36); The Adoration of the Magi (Plate 23); the Villa Lemmi frescoes (Plates 39 and 40); The Birth of Venus (Plate 66)
1483-84	Botticelli worked at the Medici Villa dello Spedaletto near Volterra on decorative frescoes.	Portrait of a Young Man (Plate 25); Portrait of Giuliano de' Medici (Plate 28); Portrait of a Young Man Holding a Medallion (Plate 27); The Story of Nastagio degli Onesti (Plate 49); Pallas and the Centaur (Plate 63)

1485		The Bardi Altarpiece (Plate 9); Madonna of the Magnificat (Plate 51); Madonna and Child with a Book (Plate 5)
1487	*	Madonna of the Pomegranate (Plate 52); Portrait of a Man with a Medal (Plate 26); Portrait of Lorenzo Lorenzano (Plate 29); Venus and Mars (Plate 61); The San Barnaba Altarpiece (Plate 10); The Annunciation (Plate 57)
1490		The Coronation of the Virgin (Plate 15); Pietà (Plate 58); The Panciatichi Pietà (Plate 59)
1491	Botticelli commissioned (18 May) to decorate vault of the Chapel of St. Zenobius in Santa Maria del Fiore (his share of the work never completed); Botticelli acted as member of the committee to consider designs for façade of Santa Maria del Fiore.	Three Angels (Plate 68); 'Noli me Tangere' (Plate 43); The 'Calumny' of Apelles (Plate 64); 'La Derelicta' (Plate 38); The Communion of St. Jerome (Plate 44); St. Augustine in his Cell (Plate VI); Madonna and Child with Three Angels (Plate 53)
1496	Botticelli painted a fresco of St. Francis in the dormitory of Santa Maria di Monticelli (the building destroyed 1529–30).	Scenes from the Life of St. Zenobius (Plates 45–48); Pentecost (Plate 60)
1497	Botticelli and assistants commissioned to paint decorative frescoes for the Medici Villa di Castello.	
1497-1500		The Annunciation (Plate VII)
1500		. The Mystic Nativity (Plate IV); The Agony in the Garden (Plate 24); The Story of Virginia (Plate 41); The Story of Lucretia (Plate 42); the Divina Commedia illustrations (Plates 70-73)
1504	Botticelli acted as member of the committee to decide on placing of Michelangelo's <i>David</i> .	
1510	Death of Botticelli; buried in Ognissanti (17 May).	

Bibliography

The giant monograph by Herbert P. Horne, Alessandro Filipepi, commonly called Sandro Botticelli (London 1908) is irreplaceable. It is painstakingly researched and quotes documents in full, including the relevant text of the Anonimo Gaddiano, originally written c. 1542–48, and both editions of Vasari's Life of Botticelli (1550 and 1568). Yukio Yashiro's Sandro Botticelli and the Florentine Renaissance (London 1929) is more passionately written and contains a useful chronology and extensive bibliography. For quick reference Roberto Salvini, Tutta la pittura del Botticelli, 2 vols. (Milan 1958) and The Complete Paintings of Botticelli, introduction by Michael Levey and with notes and catalogue by Gabriele Mandel (English edition, London 1970), are both easy to use. The most recent publications are L. D. and Helen

S. Ettlinger, Botticelli (London 1976), Kenneth Clark, The Drawings by Sandro Botticelli for Dante's 'Divine Comedy' (London 1976) and a new monograph by Ronald Lightbown, Botticelli (London 1977). Of all the museum and gallery catalogues containing works by Botticelli, Martin Davies's National Gallery: The Earlier Italian Schools (2nd edition, London 1961) remains the most informative.

Rather than attempt to give a definitive bibliography which could cover several pages, I list here sources which have been quoted in my text and in general those books or articles which, in addition to the ones cited above, have proved most useful in the compilation of this book.

Francesco Albertini, Memoriale di Molte Statue et Picture di Florentia (Florence 1510) reprinted in Gregg International Publishers' Five Early Guides to Rome and Florence (Farnborough 1972).

Aldo Bertini, Drawings by Botticelli (New York 1968).

Francesco Bocchi, Bellezze della Città di Firenze (Florence 1591) and the Giovanni Cinelli edition of 1677.

P. Cannon-Brookes, 'Botticelli's "Pentecost", An Interpretation', Apollo (1962).

Julia Cartwright, Sandro Botticelli (London 1903).

J. A. Crowe and G. B. Cavalcaselle, *The History of Italian Painting* (Langton Douglas edition in English) (London 1911).

Kenneth Clark, Another Part of the Wood (London 1974).

- C. Dempsey, 'Botticelli's Three Graces', The Journal of the Warburg and Courtauld Institutes (1971).
- C. Dempsey, 'Mercurius Ver: The Sources of Botticelli's "Primavera", The Journal of the Warburg and Courtauld Institutes (1968).
- L. D. Ettlinger, The Sistine Chapel before Michelangelo (Oxford 1965).
- E. H. Gombrich, 'Apollonio di Giovanni', The Journal of the Warburg and Courtauld Institutes (1955).
- E. H. Gombrich, 'Botticelli's Mythologies', The Journal of the Warburg and Courtauld Institutes (1945).
- C. Grayson, Leon Battista Alberti: On Painting and On Sculpture (London 1972).

Martin Kemp, 'Botticelli's Glasgow "Annunciation": Patterns of Instability', The Burlington Magazine (1977).

Michael Levey, 'Botticelli and 19th century England', The Journal of the Warburg and Courtauld Institutes (1960).

Michael Levey, Themes and Painters in the National Gallery Number 11: Botticelli (London 1974).

- F. Lippmann, Drawings by Sandro Botticelli for Dante's 'Divina Commedia' (London 1896).
- M. Meiss, The Great Age of Fresco (London 1970).

- W. and E. Paatz, Die Kirchen von Florenz (Frankfurt-am-Main 1955).
- J. G. Phillips, Early Florentine Designers and Engravers (Cambridge, Massachusetts 1955).
- H. Ruhemann, 'Technical Analysis of an Early Painting by Botticelli', Studies in Conservation (1955).
- John A. Symonds, Renaissance in Italy, The Fine Arts (London 1877).
- Agostino Taja, Descrizione del Palazzo Apostolico Vaticano (Rome 1750).
- G. F. Waagen, Works of Art and Artists in England (London 1838).
- H. Wölfflin, Classic Art (first published 1899; English edition, London 1952).
- F. Zeri, La Galleria Pallavicini in Roma (Florence 1959).

Note to the Plates

All except one of Botticelli's paintings illustrated here are described as in tempera, that is, pigment suspended in an aqueous medium, usually egg. Where technical examinations of paintings have been made, notably in the case of the London Adoration of the Magi (Plate 17), it has been shown that the paintings also contain oil and oil and resin glazes carrying either dissolved dyestuffs, such as madder, or particles of pigment. The panel is probably poplar in most cases but only very rarely is the wood-type specified in museum catalogues.

(opposite)

I Primavera (detail of Plate 65)
(overleaf)

II The Birth of Venus (see Plate 66)

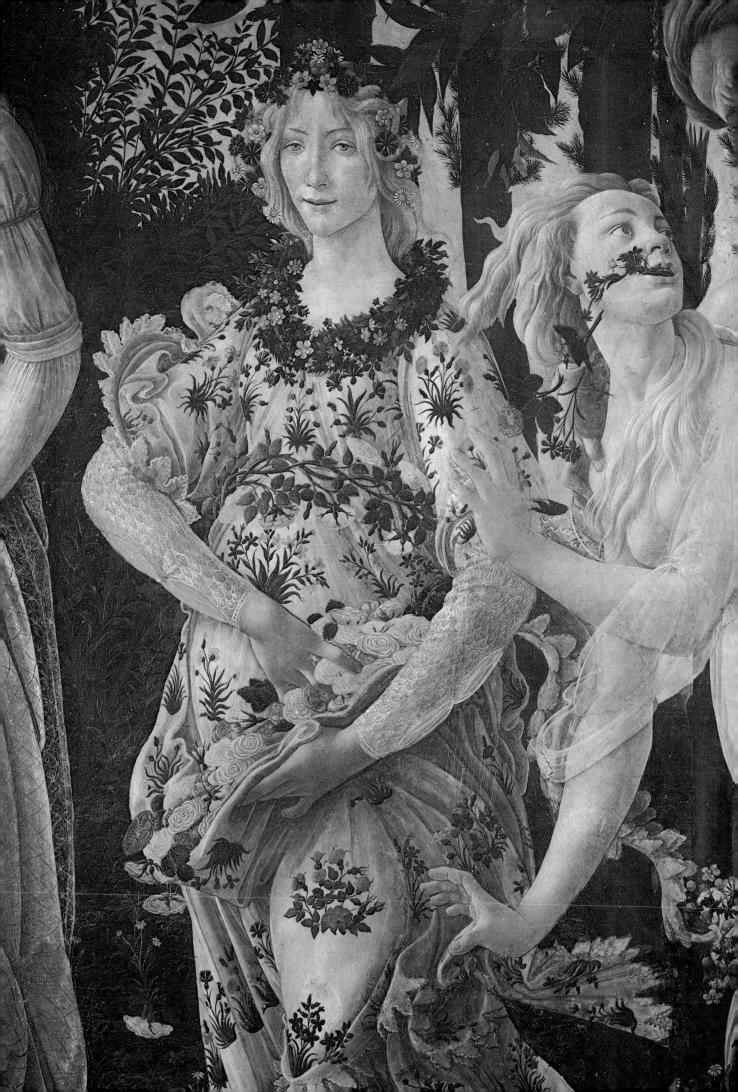

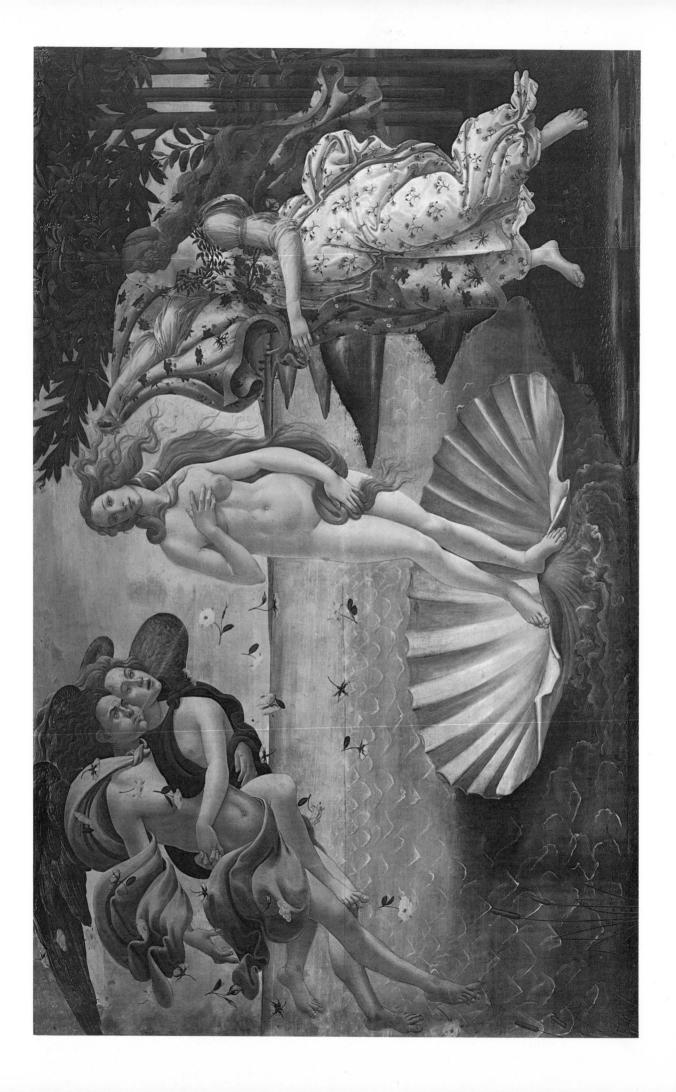

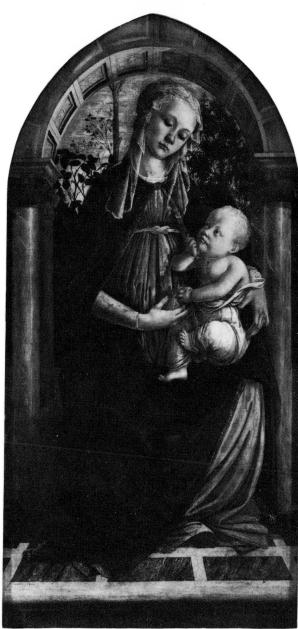

(above left)

1 Madonna and Child in a Mandorla of Seraphim Florence, Galleria degli Uffizi. Tempera on panel 120×65 cm. Original frame. Suffering from rubbing, losses in areas of gilding and a coating of discoloured varnish.

The early history of the panel is unknown, but it was recorded without an attribution in a Uffizi inventory of 1784. In 1893 it was published in Ulmann's Sandro Botticelli, since when it has been accepted as one of the artist's earliest works, painted before the Fortitude (Plate 6) which is known to have been finished by August 1470. Diffidently composed, carefully excluding the complexities of spatial description, this picture nevertheless incorporates in embryonic form many of the stylistic idiosyncrasies of Botticelli's mature work. The oversize Child, for example, reappears only slightly refined in The San Barnaba Altarpiece (Plate 10) of at least twelve years later, and the uncomfortably long arm of the Madonna is resolved as a graceful and positive feature of the design in such figures as the Venus of The Birth of Venus (Plate 66).

 $(above\ right)$

2 Madonna and Child in an Archway (Madonna del Roseto) FLORENCE, Galleria degli Uffizi. Tempera on panel 124 × 64 cm.

This panel hung in the old Camera di Commercio on the east side of the Piazza della Signoria before it was moved to the Uffizi in the eighteenth century. Its original location is unknown. It is a far more confident painting than the *Madonna and Child in a Mandorla of Seraphim* (Plate 1), and despite the fact that Morelli, in 1897, judged it a 'bastarda opera', most authors agree in attributing it to Botticelli and the period of the *Fortitude* (Plate 6), around 1470.

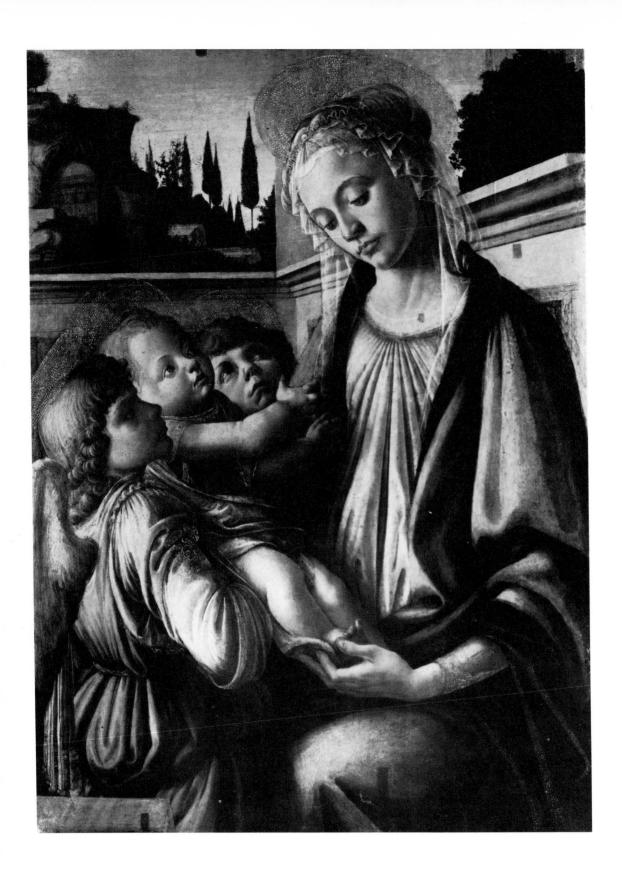

3 Madonna and Child with Two Angels Naples, Gallerie Nazionale di Capodimonte. Tempera on panel 100×71 cm. Almost entirely repainted until restoration in 1957.

This *Madonna* was first recorded in 1697 in the Palazzo Farnese, Rome, attributed to Filippino Lippi. The image of two angels presenting Christ to his mother was derived from Filippo Lippi and is best known in his *Madonna Adoring the Divine Child* of 1457 in the Uffizi. Although this picture by Botticelli still belongs to his earliest period of 1468–70, a degree of finesse in the treatment of draperies is already present. The Madonna's transparent veil provides a foretaste of the dazzling brushwork which later clothes the Graces in the *Primavera* (Plate 65).

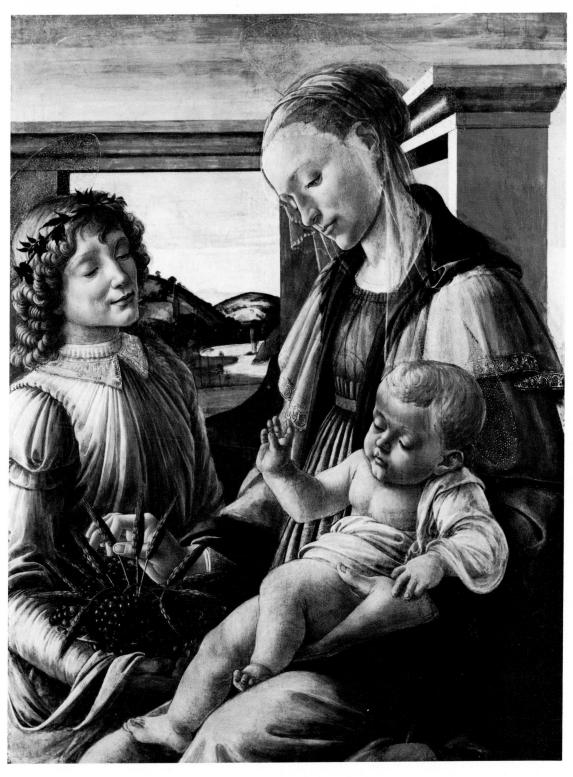

4 Madonna and Child with an Angel with Symbols of the Eucharist (Madonna dell' Eucharista) BOSTON, Isabella Stewart Gardner Museum. Tempera on panel 85×64.5 cm.

The composition of grapes and ears of wheat which the Child is blessing allude to the wine and bread of Communion. In the collection of the Principe Chigi, duca d'Ariccia, by the eighteenth century, this painting was sold in 1899 to Edmund Despretz. In the same year it was bought by Mrs. Gardner through Berenson from Colnaghi in London. It arrived in Boston in 1901 after being exhibited in London. Sir Charles Eastlake recorded in his Notebook I of 1856 that he saw this Madonna and Child, a 'good composition', in the Palazzo Chigi, Rome, attributed to Ghirlandaio. Although he had difficulty judging its quality through the grime which then coated its surface, he considered it to be by Filippino Lippi or Botticelli. It is generally stated that Morelli confirmed in 1891 the 'traditional' attribution to Botticelli, but if Eastlake's notes are correct this tradition cannot have dated back earlier than 1856. It is quite possible that Eastlake was the first to propose the Botticelli attribution. The panel may date from the period immediately after the Fortitude (Plate 6) when Botticelli, as evidenced by the facial types, was still under the influence of Pollaiuolo and Verrocchio.

5 Madonna and Child with a Book (Madonna del Libro) MILAN, Museo Poldi-Pezzoli. Tempera on panel $58\times39\cdot5$ cm. Heavy overpainting removed in restoration of 1951.

For clarity of composition and tenderness of expression this *Madonna* of the 1480s is unsurpassed in Botticelli's *oeuvre*. It was first catalogued in the Poldi-Pezzoli collection as a work of Botticelli in 1881, and since then most scholars have recognized its connection, both in terms of style and technique, with the *Madonna of the Magnificat* (Plate 51).

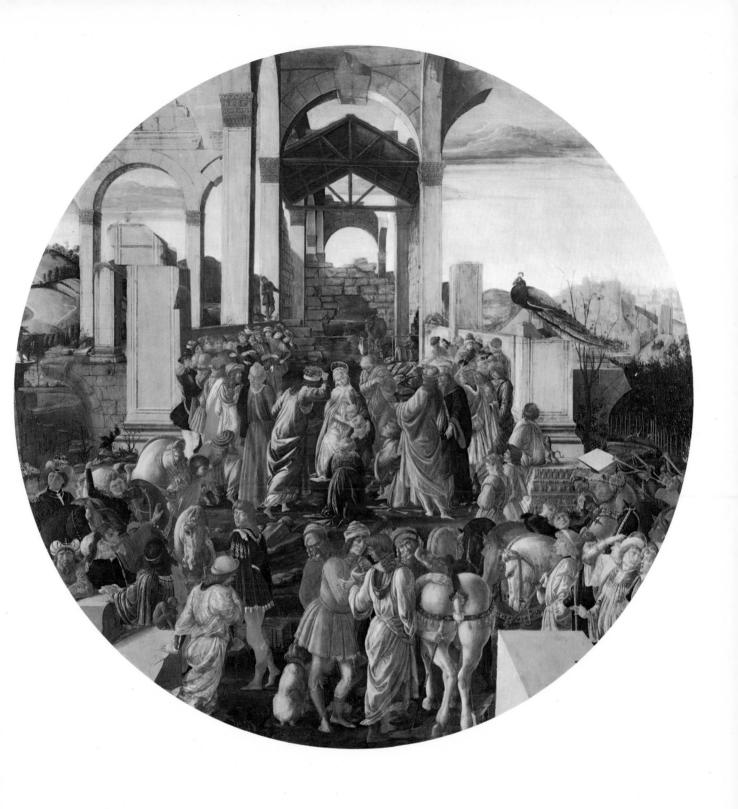

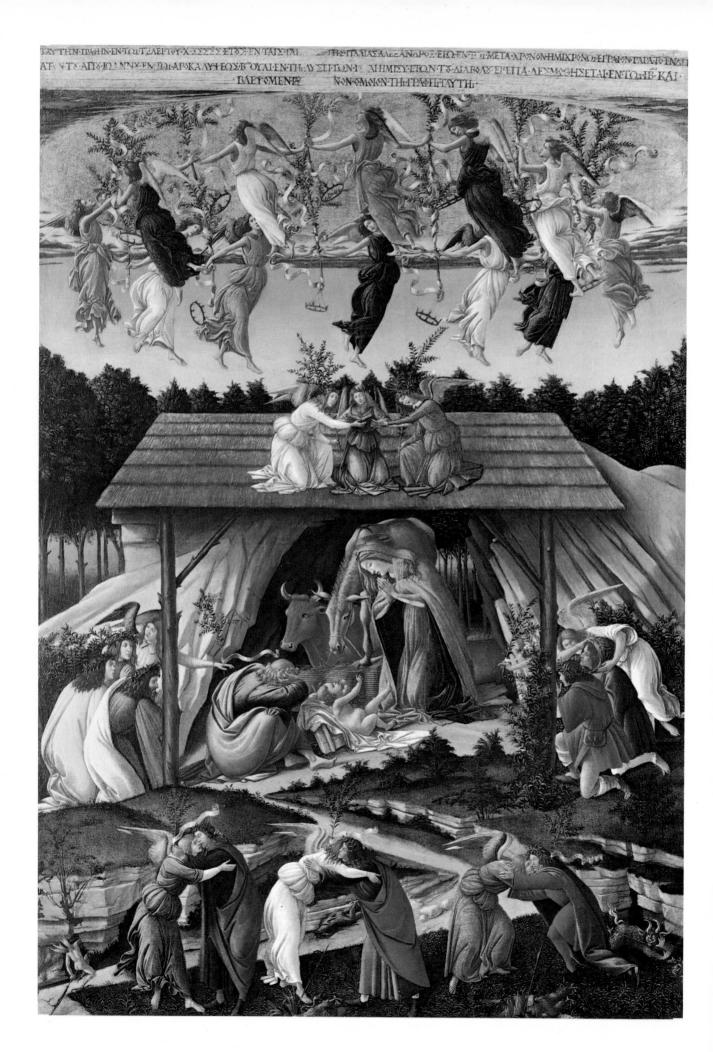

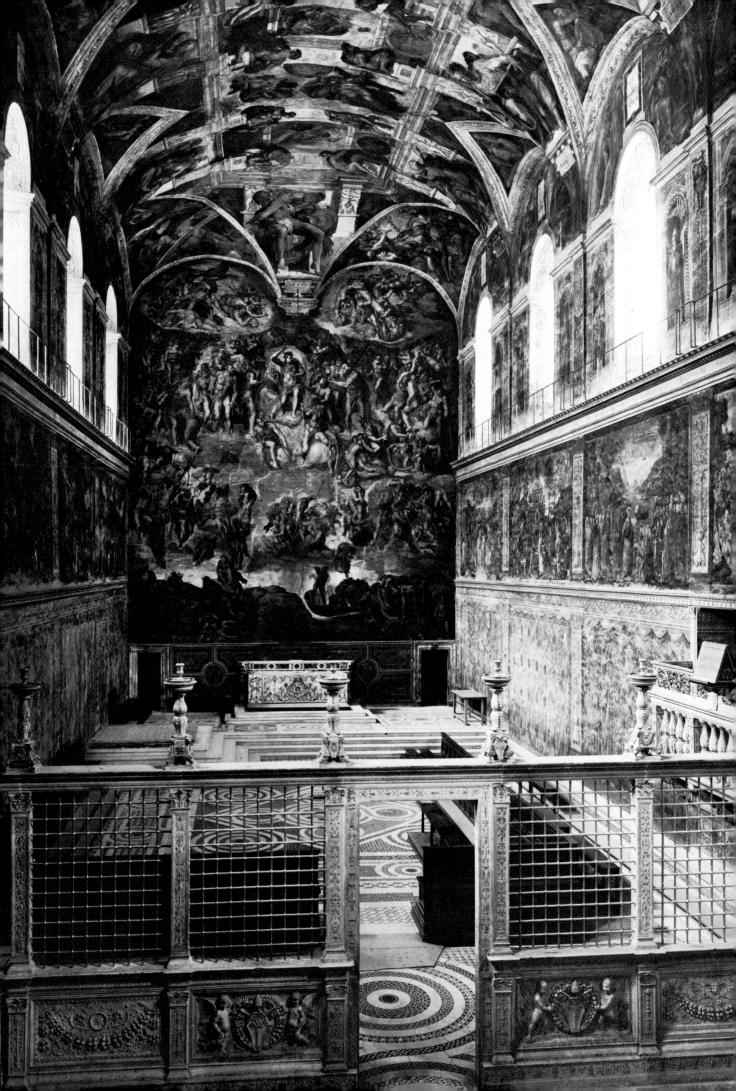

31 Moses in the Desert: his Vocation vatican city, Sistine Chapel. Fresco 348.5×558 cm.

The Life of Moses series of frescoes reads from the altar from right to left. Botticelli's first contribution to the left wall is Moses in the Desert, the second fresco between The Journey of Moses into Egypt by Perugino and Pinturicchio and The Passage of the Red Sea by Cosimo Roselli (see diagram, p. 54). Botticelli depicted Moses seven times, first on the right, killing an Egyptian (Exodus II, 11 ff.) and then fleeing from Pharoah to the land of Midian where, by a well (centre) he drove away shepherds who had prevented the daughters of Jethro from watering their flock (Exodus II, 15 ff.). Jethro subsequently took Moses into his family, and it was while Moses was guarding Jethro's flock that God called to him from a burning bush (Exodus III, 1 ff.) and commanded him 'put off your shoes from your feet, for the place on which you are standing is holy ground'. The last episode represented by Botticelli is on the left, the return of Moses with his family to Egypt (Exodus IV, 19 ff.).

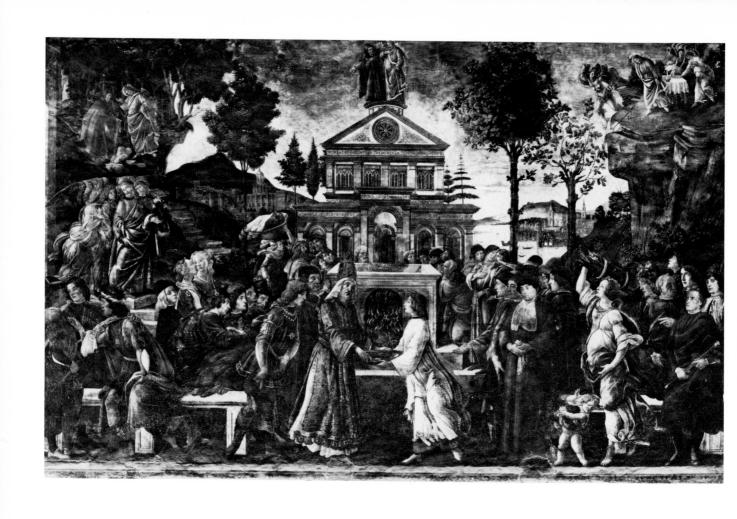

33 The Temptation and the Purification of the Leper vatican city, Sistine Chapel. Fresco 345.5×555 cm.

Although in theological terms the Moses story precedes and foreshadows the life of Christ, in the Sistine Chapel, *The Life of Christ* on the right wall was painted first. Botticelli's *Temptation* is the second fresco from the altar on the lateral wall directly opposite his *Moses in the Desert* (Plate 31) (see diagram, p. 54). The temptations are depicted in the background. First, the devil, on the left, subtly disguised in a monk's habit, attempts to persuade Christ to turn stones into bread (Matthew IV, 1–4). He then (Matthew IV, 5–7) tries to cajole Christ into leaping from the pinnacle of the Temple of Jerusalem, represented in the fresco as the Hospital of Santo Spirito, built by Sixtus IV. Finally (top right), the devil is driven away after offering in vain all the kingdoms of the earth (Matthew IV, 8–11). The main scene in the foreground shows the leper cured by Christ making an offering of thanksgiving (Matthew VIII, 1–4). Agostino Taja in his description of the Vatican of 1750 noted especially how the figures in this fresco are all in 'belle attitudini'. Many attempts have been made to identify figures in the composition with contemporaries and relations of Pope Sixtus IV.

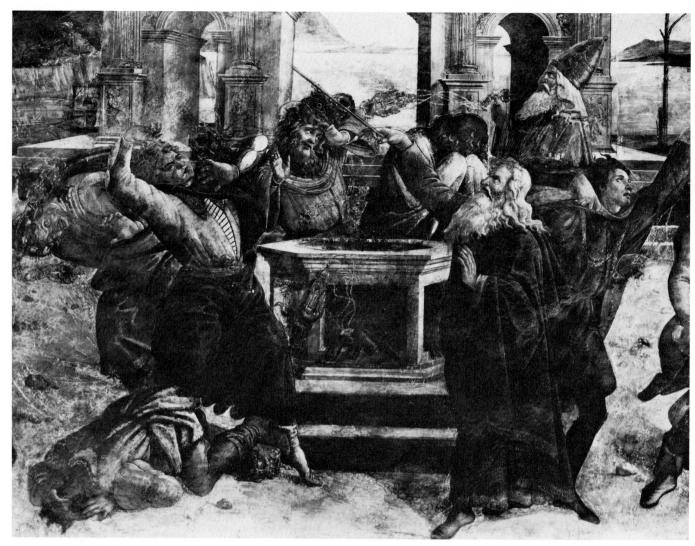

35 The Punishment of the Rebels (detail of Plate V)

(opposite)

V The Punishment of the Rebels

VATICAN CITY, Sistine Chapel. Fresco 348.5 × 570 cm.

The Punishment of the Rebels is the fifth fresco on the left wall of the Sistine Chapel (see diagram, p. 54) and the most dramatic of the three by Botticelli. Korah and his sympathizers, who refuse to accept the authority of Aaron, are summoned by Moses to appear carrying censers before Aaron. On the right of the picture the followers of Moses and Aaron retreat as 'the earth opened up its mouth' and swallowed 'all the men that belonged to Korah and all their goods'. According to the Biblical source (Numbers XVI, 1–40) the confrontation took place at the entrance of a tent, but Botticelli placed it before the Arch of Constantine on which are emblazoned the words 'Nobody takes honour on himself unless like Aaron called by God' ('NEMO SIBI ASSUMM / AT HONOREM NISI VOCATUS A DEO / TANQUAM ARON').

(page 62)

VI St. Augustine in his Cell

FLORENCE, Galleria degli Uffizi. Tempera on panel 41 × 27 cm.

In this picture a bright curtain is drawn back to give us a glimpse of a small ageing neighbourly figure only distantly related to the ecstatic *St. Augustine* of Ognissanti (Plate 37). It may be that the curtained-off sculptural setting was inspired by triumphal-arch style wall-tombs created earlier in the century by the Rosellino brothers, such as the Cardinal of Portugal's monument in San Miniato al Monte. The picture is believed to be the one mentioned by Vasari as by Filippo Lippi in the house of Bernardo Vecchietti. In the eighteenth century Ignazio Hugford of Florence sold it to Piero Pieralli, from whom it passed to the Uffizi in 1779.

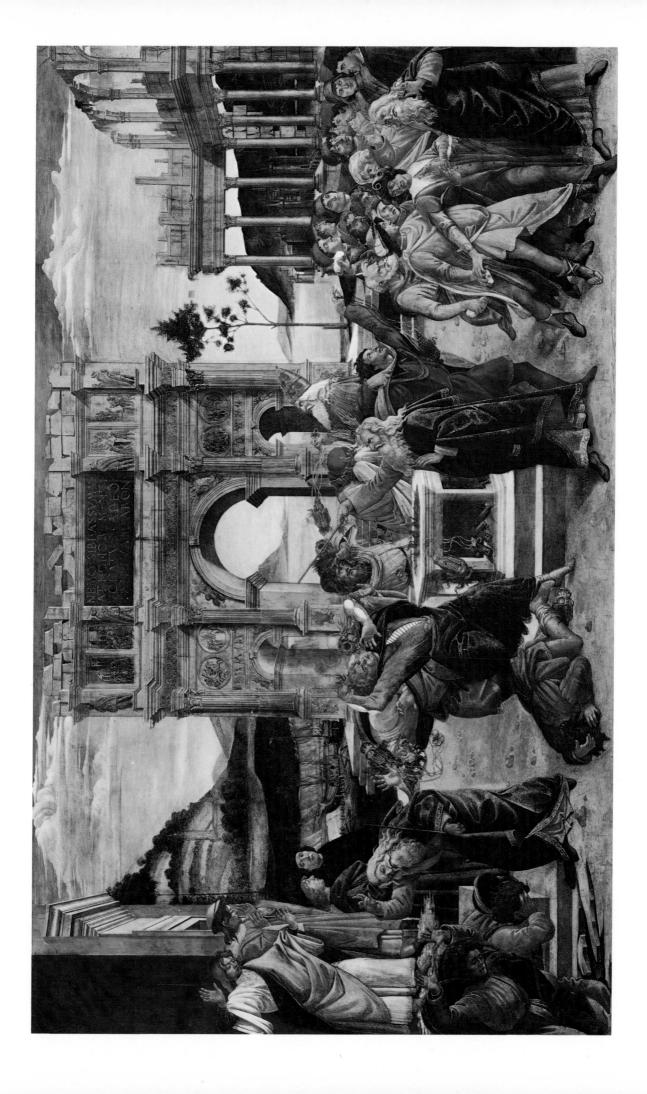

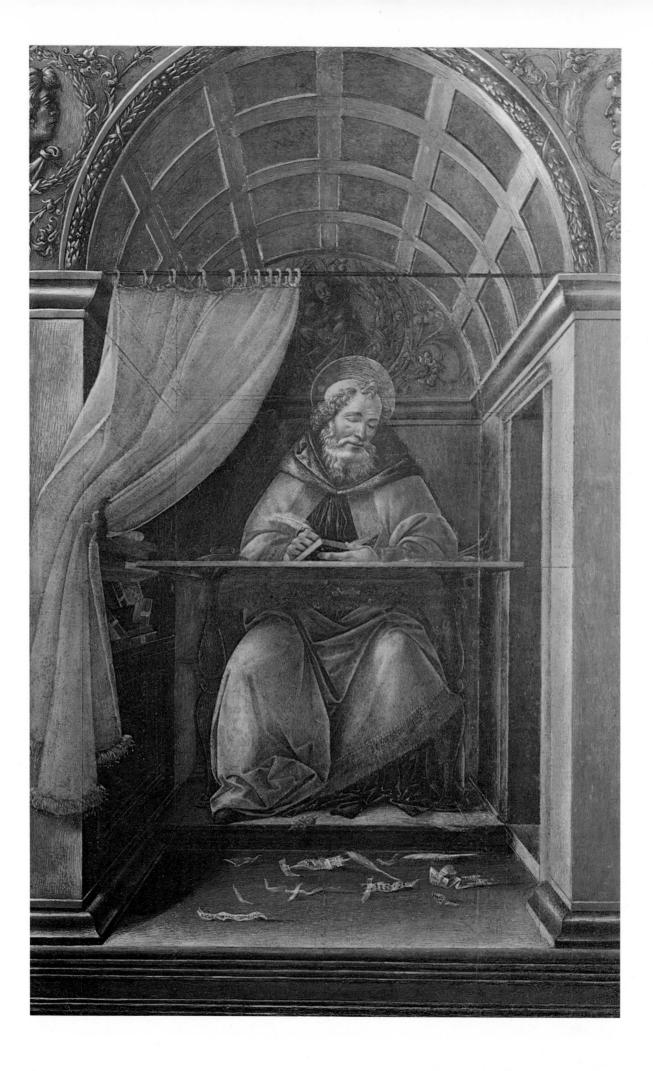

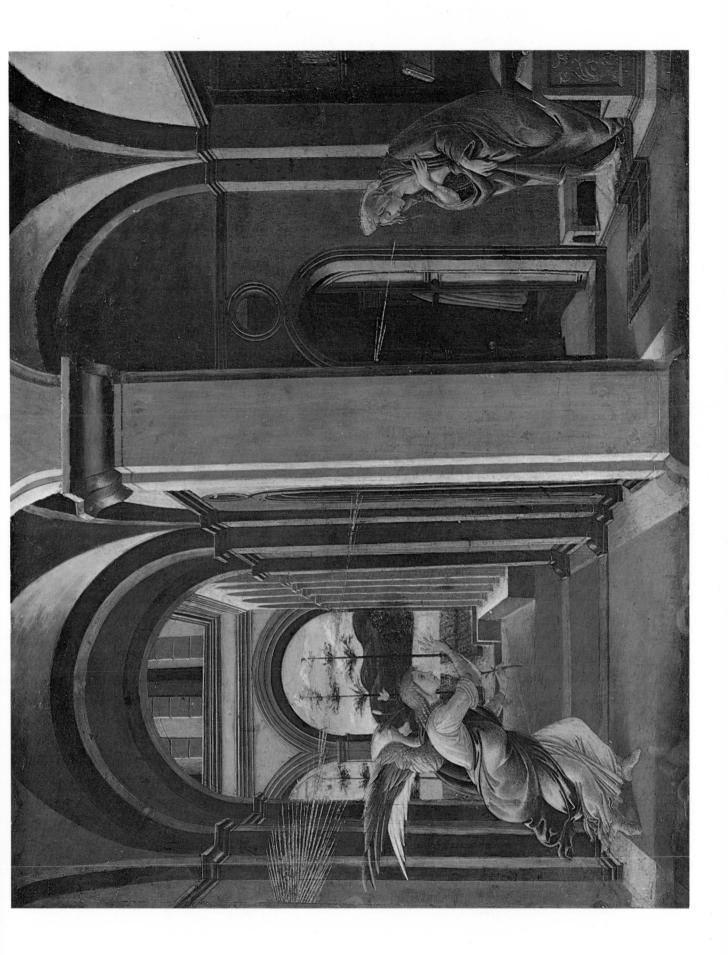

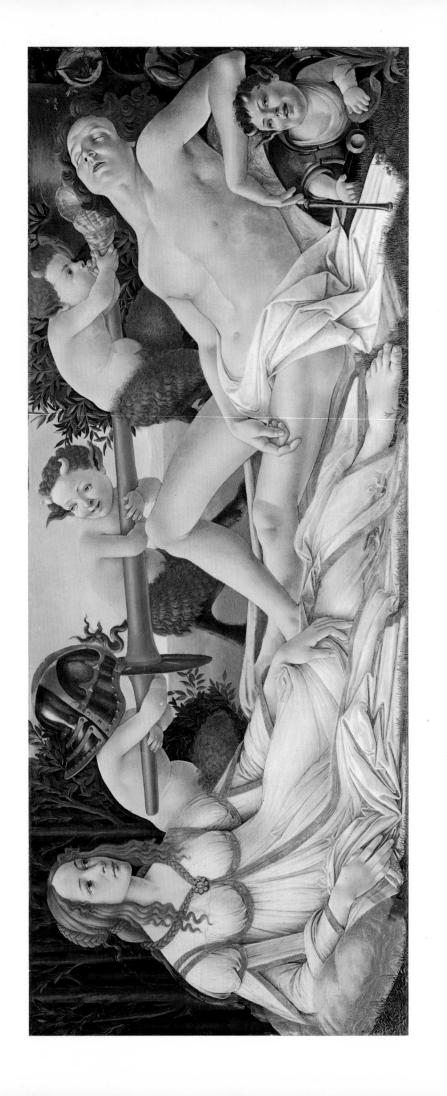

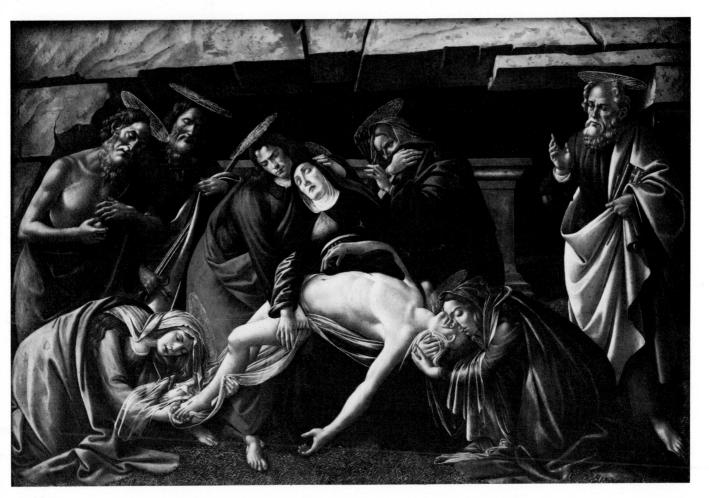

58 *Pietà* Munich, Alte Pinakothek. Tempera on panel 139·5 × 207·3 cm.

The picture was bought by Crown Prince Ludwig of Bavaria, later Ludwig I, in 1814 from the Church of San Paolino very near Botticelli's home in Florence (see map, pp. 18–19). It passed into the possession of the Bavarian state in 1850, and although it has hung as a Botticelli in the Alte Pinakothek since 1836 a number of scholars have questioned the extent of Botticelli's participation. To the eye accustomed to the decorative appeal of such popular pictures as the Madonna of the Magnifical (Plate 51), the rather bland areas of colour are somewhat disconcerting but the artist employed a rather similar style in several other pictures of his later period, notably in the Birmingham Pentecost (Plate 60) and the Uffizi Annunciation (Plate 57) commissioned in 1489. In the case of the Pietà he could well have considered a plainer style to be in sympathy with the subject. The pathos of the scene is heightened by the contrast between the pale, youthful body and beardless face of Christ and the rugged figures of the three older saints who look on. The Christ is very close to the Mars of Venus and Mars (Plate 61) in the National Gallery, London. The picture probably dates from the early 1490s, less than a decade before Michelangelo's St. Peter's Pietà.

(opposite)

VIII Venus and Mars (see Plate 61)

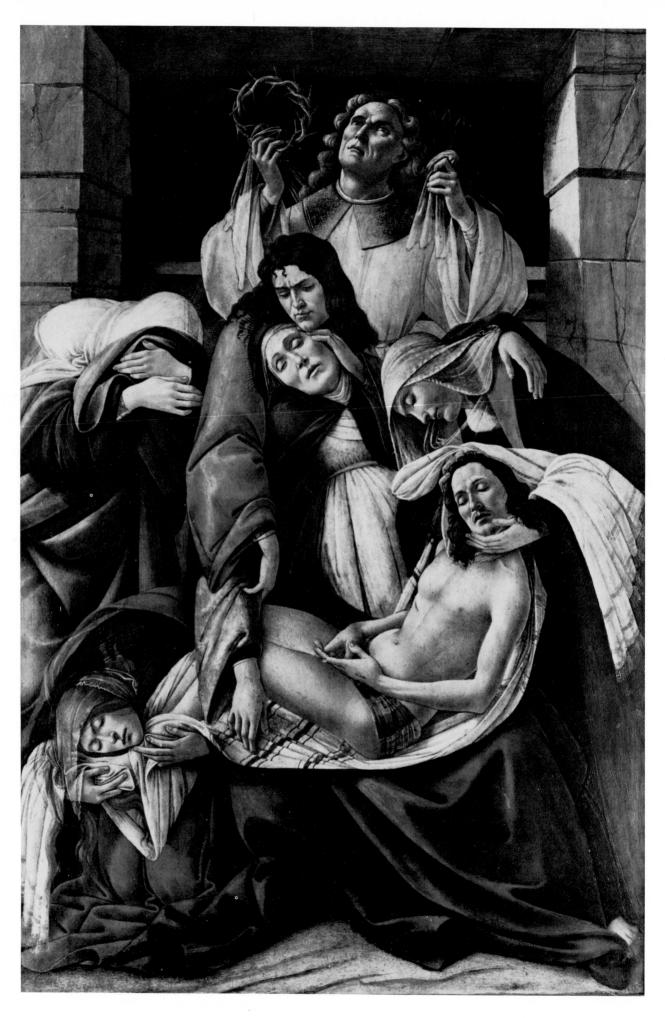

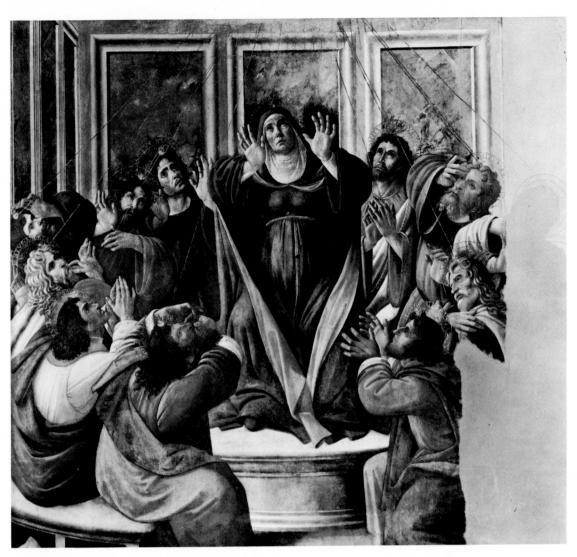

60 Pentecost BIRMINGHAM, City Art Gallery. Tempera on panel 221 × 229 cm. Numerous losses and old retouchings; restored 1973.

The picture was purchased by Birmingham in 1959 from Julius Weitzer after an export licence had been refused to Bob Jones University, Greenville, South Carolina. Mandel and Salvini mistakenly catalogue it as at Greenville. Earlier the *Pentecost* had been in the Cook collection, Richmond and immediately before that, until 1874, with the Abbé Hyeres at the Jesuit College, Lyons. He had purchased it in 1872 from Michele and Luigi Gamberini who believed it to be *The Convertite Altarpiece* (cf. Plate 8). The subject is from Acts II, 1–4: 'they were all together in one place. And suddenly a sound came from heaven like the rush of a mighty wind, and it filled all the house where they were sitting. And there appeared to them tongues as of fire, distributed and resting on each one of them. And they were all filled with the Holy Spirit . . .' Cannon-Brookes has pointed out that the composition follows a type usually found in miniatures. The subject is rarely found on any larger scale but the great round window of Santo Spirito is decorated with a *Pentecost* designed by Perugino in about 1500. In Perugino's composition the Apostles are similarly grouped in a circle round the Virgin, but they are standing rather than seated. Botticelli's picture is probably slightly earlier than the window design, dating from the period between the Munich and the Panciatichi *Pietàs* (Plates 58 and 59) and *The Mystic Nativity* (Plate IV).

(opposite)
59 The Panciatichi Pietà
MILAN, Museo Poldi-Pezzoli. Tempera on panel 107×71 cm. Restored 1951; extensive overpainting removed.

Like the early St. Sebastian (Plate 7) this panel hung on one of the pillars in Santa Maria Maggiore. Vasari mentioned it in the second edition of his Vite (1568), 'at the side of the Chapel of the Panciatichi' ('allato capella di Panciatichi'). The picture was in the sacristy by 1755. The Museo Poldi-Pezzoli acquired it from the antiquarian Baslini in 1855. Only since restoration has it emerged as an undoubted autograph work of Botticelli related in style and probably in date to the Munich Pietà (Plate 58). A bad copy in the Bautier collection, Brussels, has sometimes mistakenly been associated with Botticelli's studio.

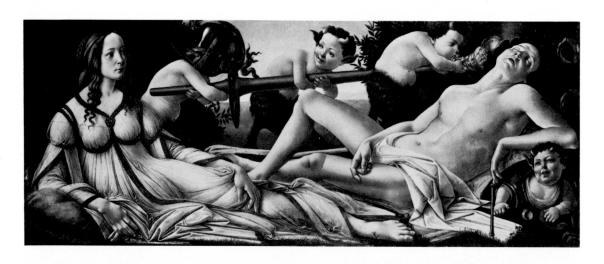

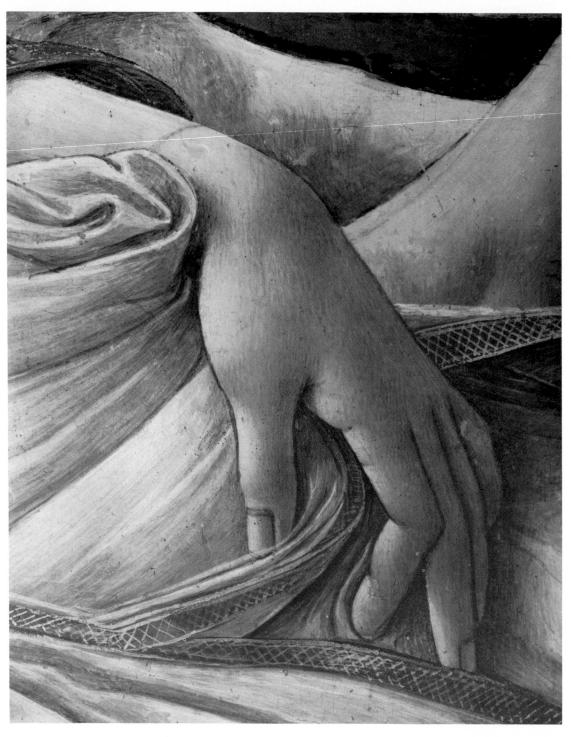

(opposite top)
61 Venus and Mars (see Plate VIII)
LONDON, National Gallery. Tempera on panel 69 × 173.5 cm.

Botticelli's only major mythological picture to be found outside Italy, Venus and Mars was purchased between 1864 and 1869 by Alexander Barker in Florence and bought by the National Gallery at the Barker sale in 1874. There is no record of its earlier provenance, but Gombrich has suggested that the wasps (vespe) near Mars's head may refer to the Vespucci family by whom Botticelli is known to have been employed (cf. Plates 41 and 42). There can be no definitive analysis of the subject, but it appears to be Love, personified by Venus, transcending War, Mars, asleep and disarmed by satyrs. The picture must date from the mid to late 1480s. The Venus is very close in type to the St. Catherine of The San Barnaba Altarpiece (Plate 10) of 1488–90. John Addington Symonds harboured an irrational dislike for the picture and for Mars in particular: 'The face and attitude of that unseductive Venus . . . opposite her snoring lover, seems to symbolise the indignities which women have to endure from insolent and sottish boys with only youth to recommend them.'

(opposite bottom)
62 Venus and Mars (actual-size detail of Plate 61)

(overleaf)
63 Pallas and the Centaur
FLORENCE, Galleria degli Uffizi. Tempera on canvas 207 × 148 cm. Probably transferred from panel.

This picture has had a chequered history. It was once at Castello in the collection of Lorenzo and Giovanni di Pierfrancesco de' Medici and then in that of Giovanni 'delle Bande Nere' de' Medici. It was still at Castello in 1638 but went to the Palazzo Pitti around 1830. It was 'rediscovered' in about 1893 in, according to Julia Cartwright, 'a dark corner of the Pitti Palace', and moved to the Uffizi. Its appearance is marred today by the presence of numerous faded retouchings covering most areas of the canvas. The dress of Pallas is decorated with the personal badge of Lorenzo 'il Magnifico'. Several political interpretations of the picture have been proposed but latterly scholars have preferred to see it as related to Marsilio Ficino's concept of the duality of the soul, half-animal and sensual and half-human and capable of reason. Pallas Athena or Minerva, Wisdom, guides or restrains the centaur, a creature of visibly dual nature.

(page 87)
64 The 'Calumny' of Apelles
FLORENCE, Galleria degli Uffizi. Tempera on panel 62 × 91 cm.

Lucian, the Greek writer of the second century A.D., described in detail the Calumny painted by his compatriot Apelles in the fourth century B.C. Apelles was the official painter to the Macedonian court and reputedly the only man allowed to portray Alexander the Great. Alberti paraphrased Lucian's description in his De Pictura, Book III, paragraph 53, thus: 'In the painting there was a man with enormous ears sticking out, attended on each side by two women, Ignorance and Suspicion; from one side Calumny was approaching in the form of an attractive woman, but whose face seemed too well versed in cunning, and she was holding in her left hand a lighted torch, while with her right she was dragging by the hair a youth with his arms outstretched towards heaven. Leading her was another man, pale, ugly and fierce to look upon, whom you would rightly compare to those exhausted by long service in the field. They identified him correctly as Envy. There are two other women attendant on Calumny and busy arranging their mistress's dress; they are Treachery and Deceit. Behind comes Repentance clad in mourning and rending her hair, and in her train chaste and modest Truth.' The sculptural setting in Botticelli's painting was probably intended to evoke the spirit of a classical age, but the figures and reliefs do not relate stylistically to known classical pieces, and they represent a miscellany of subjects both Christian and mythological. The figure of St. George in the niche on the central column appears to be derived from Andrea Castagno's Pippo Spano fresco in Sant' Apollonia, Florence. The figure of 'Modest Truth' on the left, like the Venus of The Birth of Venus (Plate 66), is related to the classical sculpture Venus Pudica. Proposals for dating this picture vary between 1485 and 1495. It was presented by Botticelli to Antonio Segni of Florence, according to Vasari, who saw it in his son Fabio Segni's house. It passed to the Pitti and then in 1773 to the Uffizi.

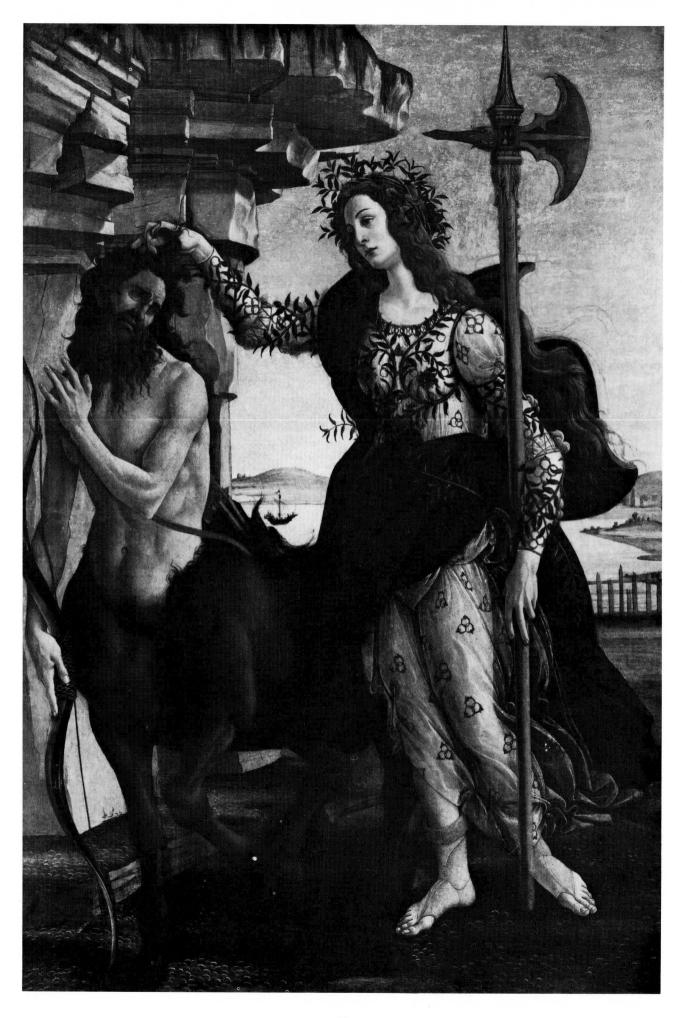

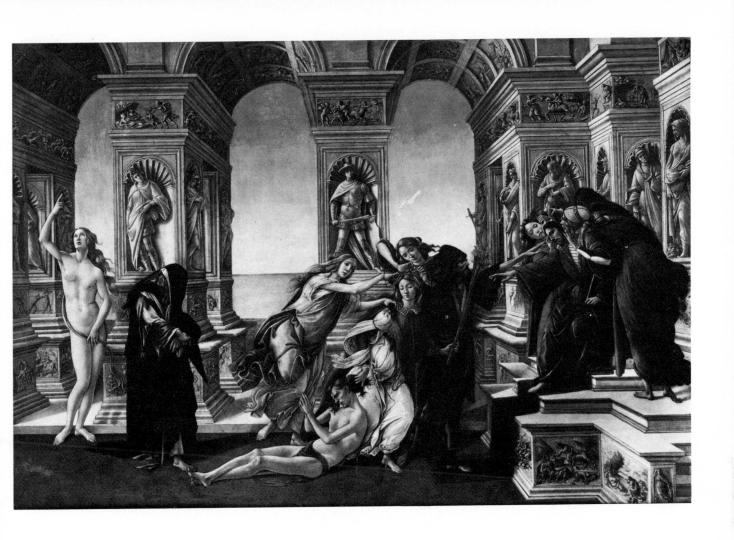

(overleaf)
65 Primavera (Spring)
FLORENCE, Galleria degli Uffizi. Tempera on panel 203 × 314 cm.

Lorenzo di Pierfrancesco de' Medici, who inherited a fortune at the death of his father Pierfrancesco in 1476, acquired the Villa di Castello in 1477 and may have had the *Primavera* executed for this, his country home, in the following year. Interpretations of the subject of the picture are legion. Vasari rather inaccurately calls it 'a Venus, whom the Graces are covering with flowers ['lo fioriscono'] denoting spring'. As in two of the Sistine frescoes the theme (it can hardly be called narrative) reads from right to left. The impetus is given by Zephyr who blows from the right. On the left, Mercury, associated with the month of May, turns as if to indicate the passage of spring towards summer. Zephyr's breath causes flowers to spring from the mouth of the earth nymph Chloris, who then assumes the richly-clad form of Flora as the next figure in the group. Venus, the personification of April, stands in the centre of the picture gesturing towards her attendant Graces. The picture is dulled and darkened by surface dirt. It generally appears more colourful in reproduction than 'in the flesh' as the powerful lighting needed to photograph such a dark image penetrates the dust and grime. The picture remained at Castello until 1815, when it was transferred to the Uffizi. It was in the Accademia for a spell until 1919.

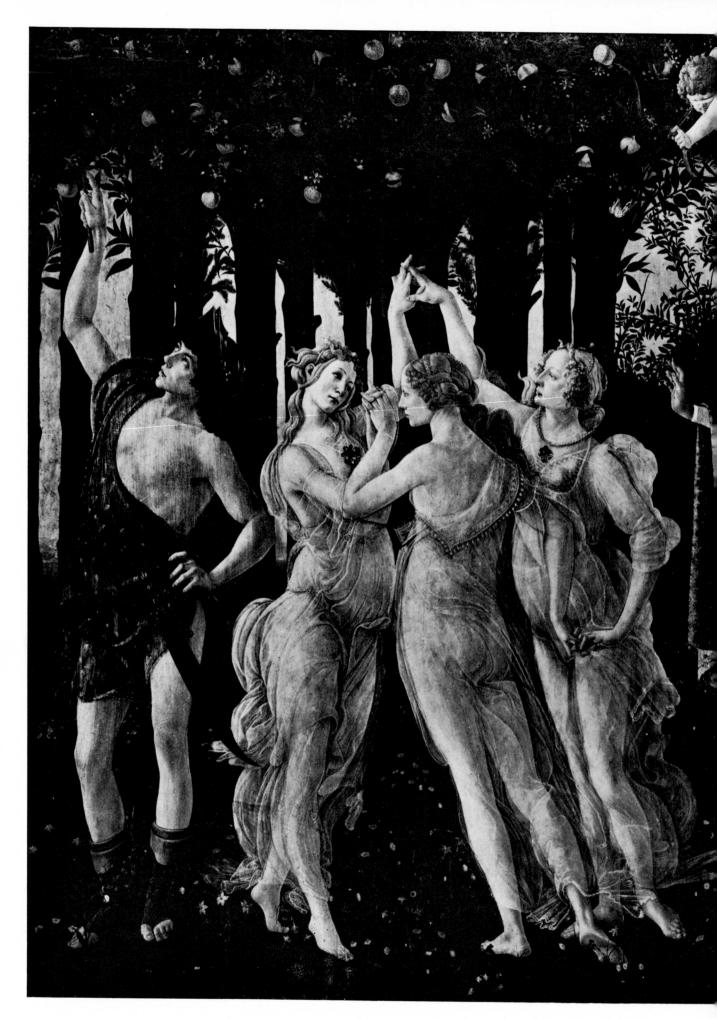

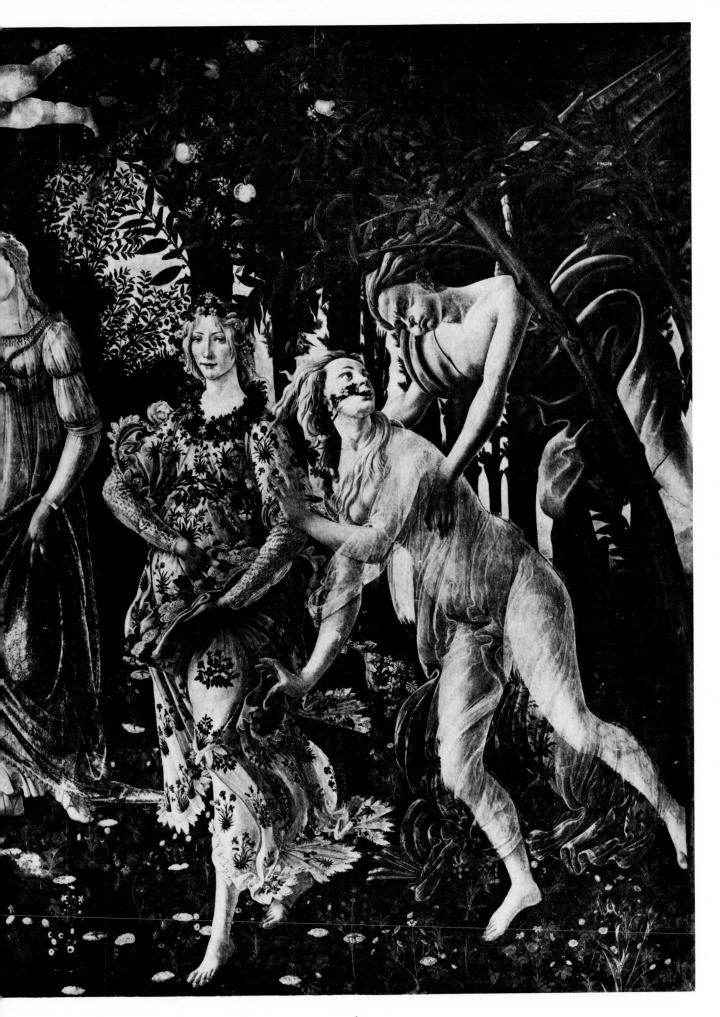

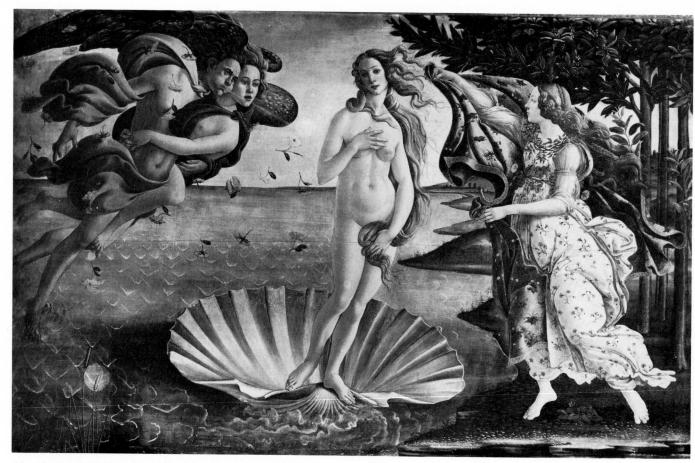

66 The Birth of Venus (see Plate II)
FLORENCE, Galleria degli Uffizi. Tempera on canvas 172.5 × 278.5 cm. Probably transferred from panel; damage along a horizontal join across the centre of the canvas has been crudely retouched.

The Birth of Venus is Botticelli's best known and most popular work, painted, like the Primavera (Plate 65), for the Villa di Castello, though not as a pendant of the earlier picture. The provenance of both paintings is the same. The theme may be related to the Neo-Platonist education of the young Lorenzo di Pierfrancesco de' Medici for whom it was painted. Letters from the tutor Marsilio Ficino to Lorenzo show that Venus was imagined not as an erotic figure but as a symbol of Humanitas, an image of beauty intended to inspire men's most noble thoughts. The picture represents Venus's spiritual birth: when Saturn castrated Heaven and threw the testicles into the sea Venus was born from the foam. The Birth of Venus was painted after Botticelli's return from Rome, in the mid-1480s.

(opposite)
67 The Birth of Venus (detail of Plate 66)

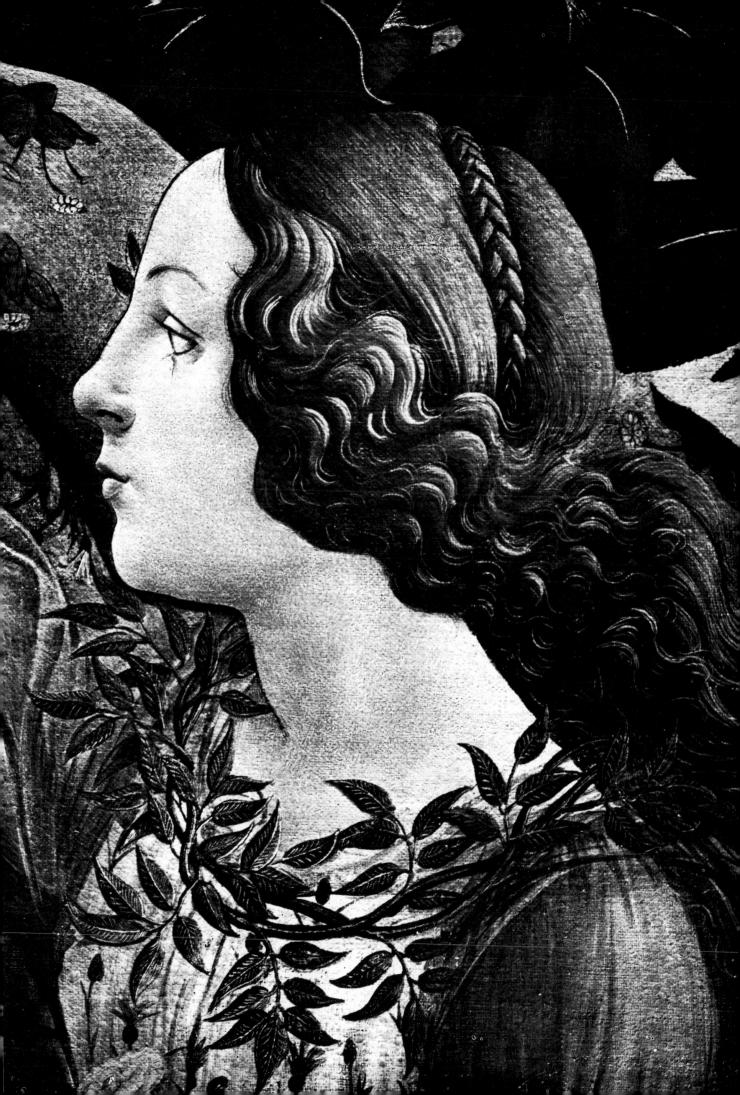

68 Three Angels
FLORENCE, Galleria degli Uffizi, Gabinetto dei Disegni e Stampe. Pen and ink on brown tinted
paper, heightened with white 10·2×23·5 cm.

Yashiro called this 'the finest example of the precision and purity of the Quattrocento drawing'.

69 Abundance LONDON, British Museum, Department of Prints and Drawings. Pen and ink and wash over black chalk with

white heightening on tinted paper 31·7 × 25·3 cm. Vasari recorded that he had in his collection several drawings by Botticelli. When Horne saw the *Abundance* it was set in what he believed to be one of Vasari's mounts, but this has since disappeared. In its more recent history it was sold by Rogers at Christie's, London in 1856 as by Verrocchio, and subsequently owned by Morris, Moore, Sir J. C. Robinson and Malcolm, from whom it passed to the British Museum in 1895. The British Museum cataloguers believe it to date from shortly after the *Primavera* (Plate 65), while Horne and others place it after Botticelli's visit to Rome.

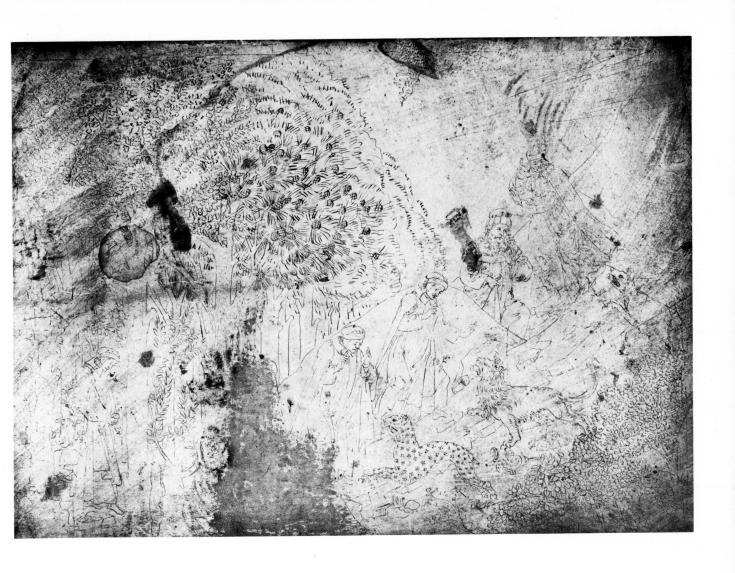

70 La Divina Commedia, Inferno, Canto I Vaticana City, Biblioteca Apostolica Vaticana. Silverpoint, pen and ink on vellum 32×47 cm.

Botticelli designed a number of illustrations for Cristoforo Landino's 1481 edition of Dante's La Divina Commedia. Nineteen of these were crudely engraved by Baccio Baldini (cf. fig. 14), and we can only guess at the quality of the original drawings as they are apparently all lost. The magnificent series of drawings which survive in Rome and Berlin is believed to be that which the Anonimo Gaddiano recorded was made for Lorenzo di Pierfrancesco de' Medici. Horne, noting that Lorenzo fled from Florence in 1497, concluded that the drawings must have been complete by that date, but Yashiro, calling them 'the beautiful suicide of Botticelli's art', placed them among the very latest of the artist's works. The Vatican sheets (Cantos I and IX–XVI) of the Inferno were acquired from Queen Christina's estate in 1690. It is not known where they were earlier. Inferno, Canto I is the beginning of La Divina Commedia. Dante, after wandering lost in a forest, finds himself at the foot of a hill over which the sun is just rising. Attempting to climb the hill, he is driven back by a panther, a lion and a wolf. In fear he turns back to the forest, but his course is changed, and the whole story set in motion, by the appearance of Virgil, who volunteers to be his guide. Beatrice hovers in the sky above. The engraving of Inferno, Canto I in Landino's Divina Commedia is close in design to this drawing.

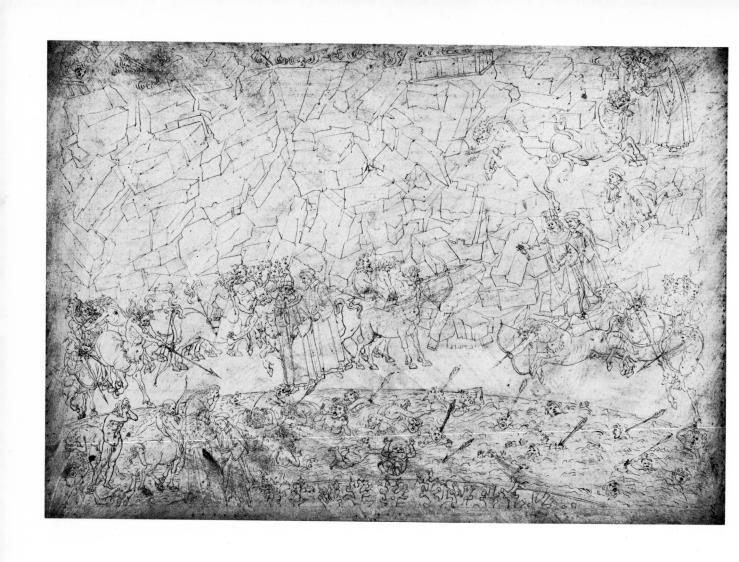

71 La Divina Commedia, Inferno, Canto XII vaticana City, Biblioteca Apostolica Vaticana. Silverpoint, pen and ink on vellum 32×47 cm.

Descending a rocky path Dante and Virgil encounter the Minotaur, whom Virgil orders aside so that they can pass. They reach a ditch filled with blood in which flounder the souls of the damned. Virgil persuades one of the herd of centaurs, who are shooting arrows at the souls, to accompany him and Dante as a guide. As in the majority of the illustrations, the protagonists, Dante and Virgil, appear more than once in the picture. The engraving of the same canto in the Landino edition of La Divina Commedia incorporates a portion of this design in reverse.

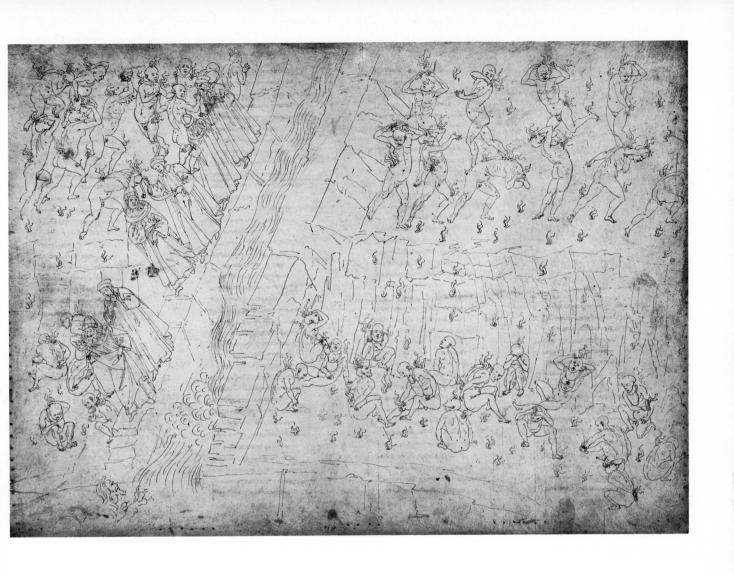

72 La Divina Commedia, Inferno, Canto XVI vatican city, Biblioteca Apostolica Vaticana. Silverpoint, pen and ink on vellum 32×47 cm.

Dante and Virgil come upon a band of sodomites doing penance in a sea of sand and shower of flames. Virgil tells Dante to unfasten the belt from his waist and lower it into the ditch where the monster Geryon, in the lower left corner, rises up and supports himself in front of them. Usurers, each with a pouch round his neck, sit at the edge of the precipice under a shower of flame. This scene, like the preceding two illustrated here (Plates 70 and 71), has a counterpart in Landino's Divina Commedia, but the composition in this case is quite different.

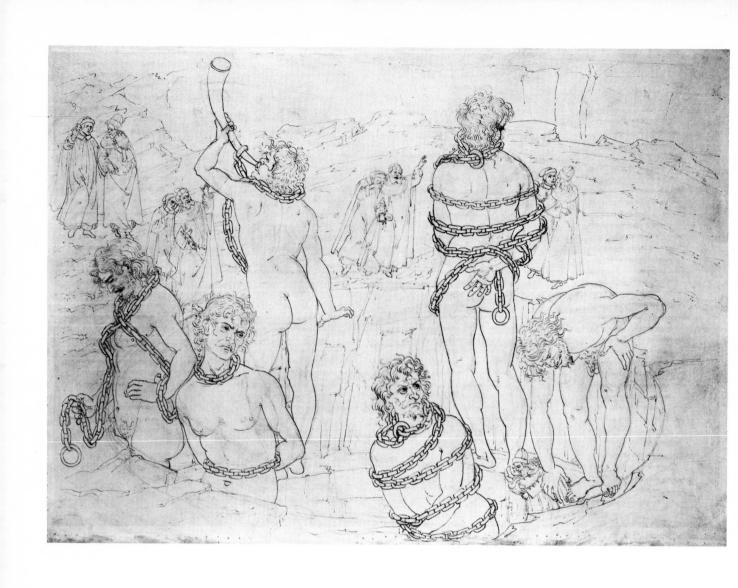

73 La Divina Commedia, Inferno, Canto XXXI BERLIN (Arnimallee), Staatliche Museen, Kupferstichkabinett. Silverpoint, pen and ink on vellum 32×47 cm.

The Kupferstichkabinett in West Berlin has illustrations by Botticelli to the *Inferno*, Cantos VIII and XVII–XXXIV and *Purgatorio*, Cantos I–VIII. In the East Berlin Kupferstichkabinett are *Purgatorio*, Cantos IX–XXXIII and the complete *Paradiso*, Cantos I–XXXII. All the Berlin drawings were acquired by the Duke of Hamilton from the dealer Claudio Molino in Paris. He sold them to Lippmann for the Berlin Museum in 1882. They were divided between East and West Berlin after World War II. In the illustration to Canto XXXI of the *Inferno* Dante and Virgil find a group of chained giants standing near a wall beyond which is the last circle of the Inferno. One of the giants, Nimrod, blows a horn, and Antaeus on the right lifts Dante and Virgil and places them inside the last circle.